PHOTOGRAPHING ON

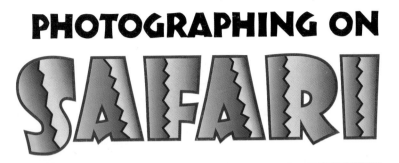

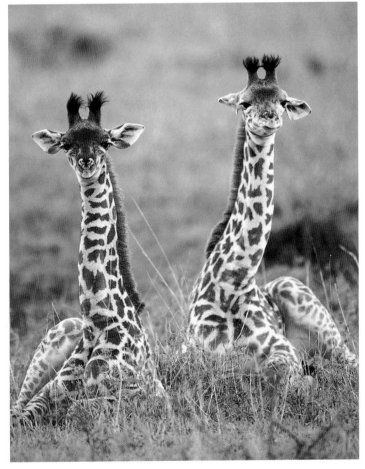

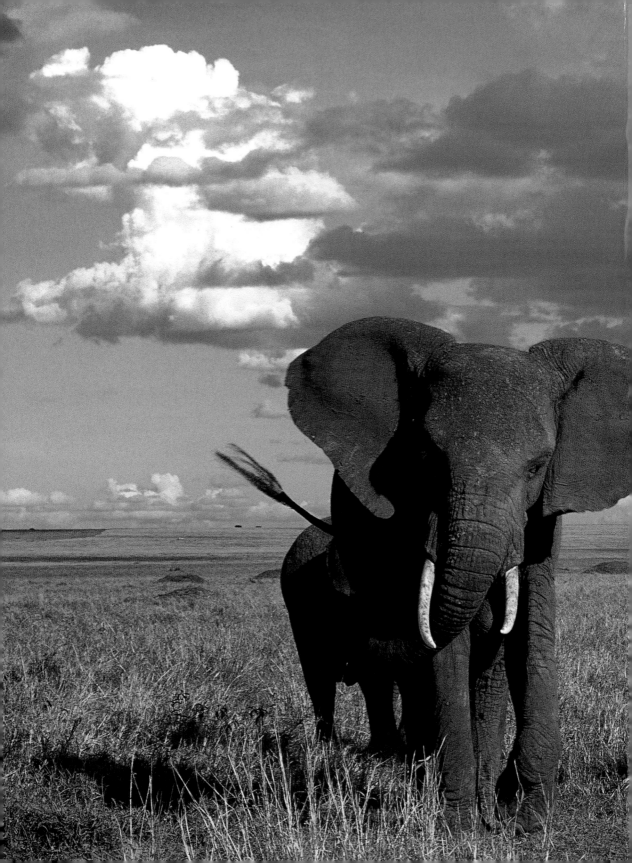

PHOTOGRAPHING ON

SAFARI

A Field Guide to Wildlife
Photography in East Africa

Joe McDonald

AMPHOTO BOOKS
An imprint of Watson-Guptill Publications/New York

Page 1:
BABY GIRAFFES
500 mm F4 lens, 1/500 sec. at f/5.6,
Fujichrome 100.

Page 2–3:
AFRICAN ELEPHANTS IN MARSH
35–70mm F2.8 zoom lens, 1/500 sec. at f/8,
Fujichrome 100.

Page 5:
CHEETAH ON HOOD OF VEHICLE
35–70mm F2.8 lens, 1/125 sec. at f/8,
Fujichrome 100.

Page 6:
LIONESS HUNTING
500mm F4 lens, 1/500 sec. at f/8,
Kodachrome 200 at ISO 250.

Copyright © 1996 Joe McDonald
First published in 1996 in New York by Amphoto Books, an imprint of
Watson-Guptill Publications, a division of BPI Communications, Inc.,
1515 Broadway, New York, NY 10036

Library of Congress Cataloging-in-Publication Data
McDonald, Joe.
 Photographing on safari : a field guide to wildlife photography in
East Africa / Joe McDonald.
 p. cm.
 Includes index.
 ISBN 0-8174-5440-3 (pbk.)
 1. Wildlife photography—Africa, East—Amateurs' manuals. 2.
Safaris—Africa, East—Amateurs' manuals. I. Title.
TR729.W54.M335 1996
778.9'32'09676—dc20 96-17751
 CIP

Printed in Hong Kong
1 2 3 4 5 6 7 8 9 / 04 03 02 01 00 99 98 97 96

Editorial concept by Robin Simmen
Edited by Alisa Palazzo
Designed by Jay Anning
Graphic production by Hector
Campbell

For my wife, Mary Ann,
may our adventures continue to grow

This book would not have been possible without the help and cooperation of many people, not the least of whom are those who have accompanied me on my safaris. I'd especially like to thank my favorite driver, David Kariithi Mgunyi, for his help and expertise on our gamedrives, and my buddy, Sam Maglione, for his idea that I do this book.

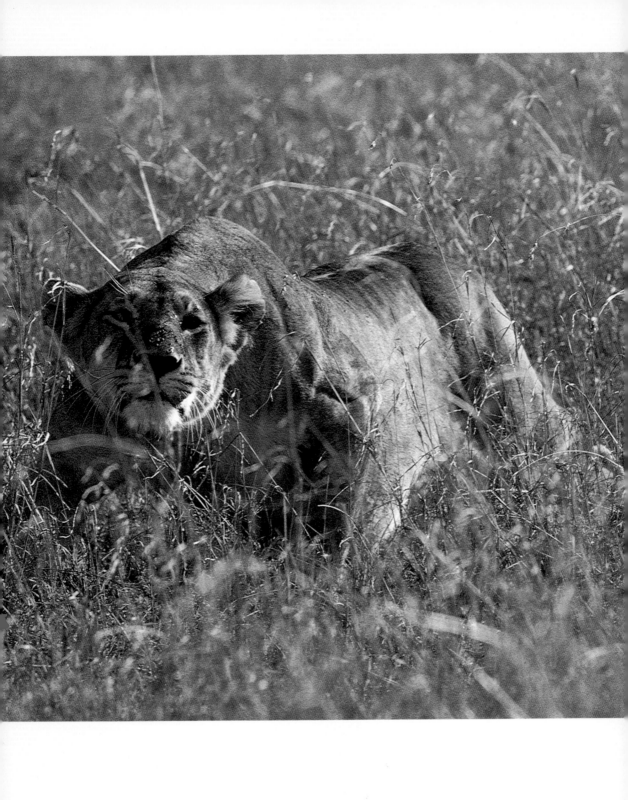

Contents

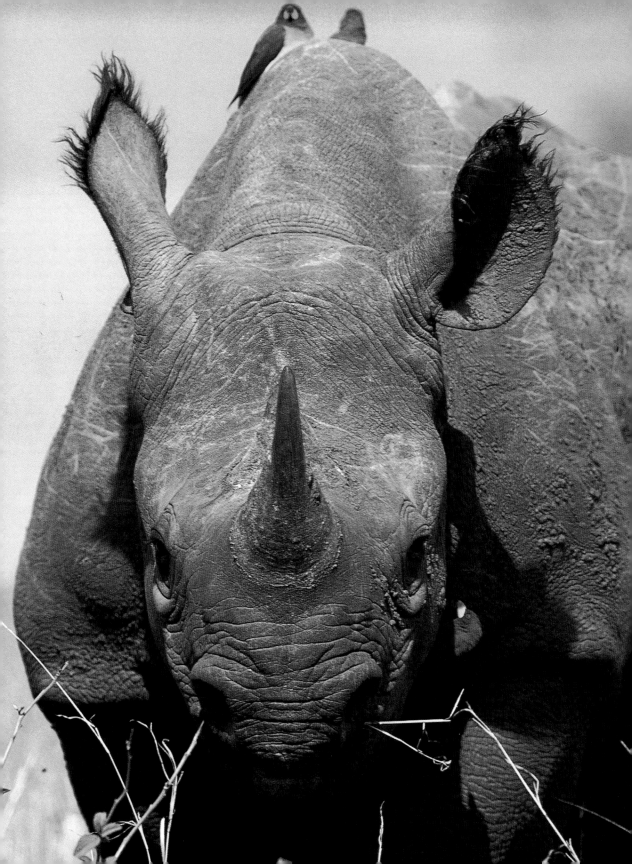

Introduction

EXCITEMENT FILLED THE AIR. In the sultry quiet of late afternoon, the harsh barks of vervet monkeys sounded the alarm. Somewhere ahead in the thick scrub bordering the riverine forest, a big cat was about, at its kill or perhaps about to make one. Confirmation came crackling over our radio, "Leopard carrying a monkey! *Haraka!* Hurry!" Grabbing our telephoto lenses, we raced to join the lead vehicle but arrived too late to see the successful hunter disappear into the bush. The danger passed, and the monkeys quieted; the leopard was gone. No matter— there'd be more leopards, or animals equally as exciting, as we continued on the first afternoon of our photo safari.

BLACK RHINOCEROS
500mm F4 lens, 1/500 sec. at f/8, Fujichrome 100.

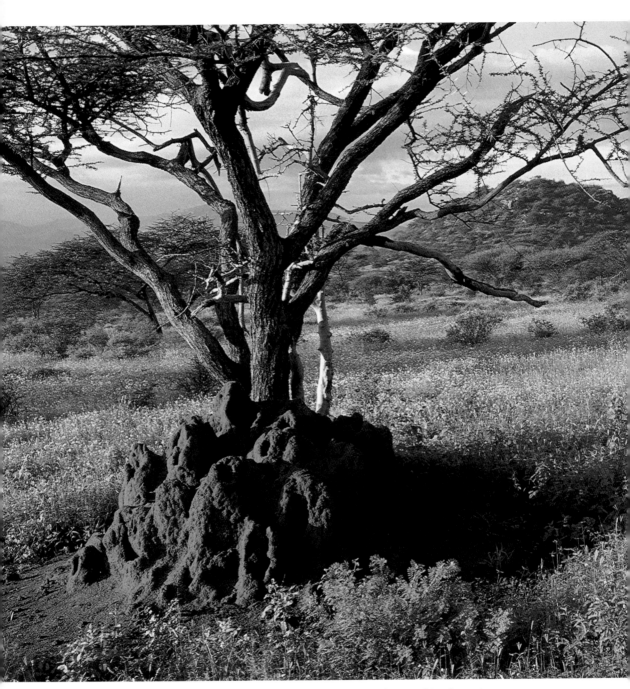

TERMITE MOUND
28–85mm F3.5–4.5 zoom lens,
1/60 sec. at f/11, Fujichrome 100.

Castlelike termite mounds are a common feature of Samburu that most photographers promise themselves they'll photograph, but never do. When the light's good, and you have an attractive subject, don't put off capturing the image.

Safari. The word evokes excitement both for those who've made the trip to East Africa and those who hope to do so. In Swahili, the most widely spoken language of the region, the word means "to travel" or "to journey," and since the first explorers pushed into this vast continent's interior, safaris have stirred our imaginations and senses of adventure. As our knowledge of Africa has grown, this increased awareness only whets our appetite and the idea of a safari still holds all its original magic and allure.

Today, a safari is, by any standard, a relatively safe and comfortable vacation with few hardships, excepting an occasional cold shower or stranded vehicle. This is worth knowing, since world headlines featuring AIDS epidemics, ebola viruses, and civil unrest so often paint a gloomy picture that taint an entire continent. Certainly, as with any travel or adventure, there is a degree of risk involved, but it is minimal compared to what the first visitors must have had to contend with.

Sometimes while on safari, I try to picture what it must have been like to explore the countryside I'm overlooking. From the safety and comfort of my vehicle, I draw the imaginary routes I'd take if I were on foot without the benefit of established roads or trails. I contemplate the dangers of less than a century ago—hostile indigenous peoples, rivers thick with hidden crocodiles, a countryside harboring dangerous game, infections, and disease. In doing so, I can only laugh at the petty inconveniences that plague the modern visitor. Potholes and road ruts, an uninteresting field breakfast, or a game drive ruined by rain all seem pretty trivial in comparison. It is so easy now, and I'm very happy that it is.

Ironically, for several years I had little interest in doing a photo safari. The images I'd seen, which were taken by friends who'd made the trip, were not motivational. In fact, for the most part their photographs were boring. Innumerable shots of sleeping lions, antelopes baking under a noon sun, and back ends of elephants or zebras made me believe my energy was best spent at home. I assumed, in error, that the many wonderful published photographs I'd seen were the product of pros on intensive, long-term shoots.

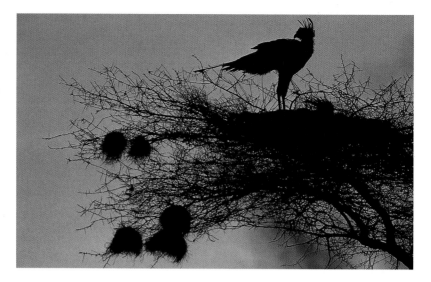

SECRETARY BIRD NEST
AT SUNRISE
*300mm F2.8 lens, 1/250 sec.
at f/11, Kodachrome 64.*

*The variety of birds in
East Africa is astounding.
This secretary bird, a
ground-hunting bird of
prey, was still on its nest
at dawn.*

Still, circumstances developed that allowed me to lead a small photo safari composed of five friends and a driver crammed into one van. I doubt that I had been in the country a day before I recognized the area's enormous potential. I was hooked, and that experience led to some of the most exciting and productive photography I've ever experienced.

Photo safaris are incredible values. Most first-timers are stunned by the photographic opportunities so readily available; I know I was. There are many great wildlife areas around the world, but few offer the accessibility, and none the diversity of species, found in East Africa. Consider the possibilities. On a typical two-week safari, for example, you could film more large mammals on a single game drive than you're likely to see in a whole week in Yellowstone National Park or Alaska's Denali National Park. In Denali, for example, you can reasonably expect to see four large mammals—grizzly bear, caribou, Dall sheep, and moose—on a week-long visit. If weather cooperates (a big "if" in Alaska) you might even photograph them. That's four species, a very poor day afield on the savannahs of East Africa.

Birdlife is equally diverse, far surpassing the bird-rich wetlands of the Florida Everglades. The numbers speak for themselves. There are around 800 recorded bird species breeding in or migrating through North America's continent and offshore waters. In Kenya, a country approximately the size of Texas, there are over 1,100 species!

Getting close to many of these birds and mammals isn't a problem, either. Many of them seem completely oblivious to photographers inside a vehicle, some exhibiting a tameness that rivals the wildlife of the Galápagos Islands. Basically, the parks of East Africa incorporate the best of the best.

Besides the game, the weather is a pleasant surprise as well. Contrary to what you might expect, the climates in the high interiors of Kenya and Tanzania, where most parks are located, is quite pleasant. The temperature and humidity is more like that of Montana in summer than that of south Florida at any season. Many visitors expect hot, humid, snake-filled jungles, but many tourists never see a jungle and fewer still ever see a snake. The best game-viewing takes place in the open savannahs (not the jungle), and as long as you stay out of Florida, you should have no trouble avoiding snakes. I've seen more snakes in one week in Florida than I have on all my trips to Africa.

Although I'm quite happy with the luck I've had so far on safari, I'm still seeking the "ultimate" shot of most of the my subjects. For example, in over 20 trips, I've never filmed a good lion kill; in fact, I've

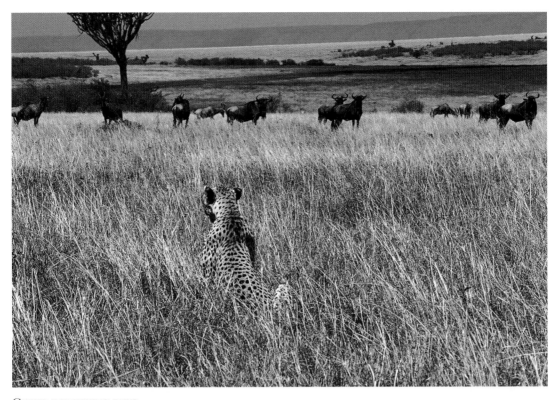

CHEETAH WATCHING GNUS
75–300mm F4.5–5.6 zoom lens, 1/125 sec. at f/16, Fujichrome 100.

Hunted animals often show no fear when they spot a predator because it is the unseen that is most dangerous.

only witnessed four lion kills as they occurred, and none of them were especially good for shooting. I've no doubt that far better images exist of every animal I've photographed, but that's okay by me. My goal, in presenting this book's portfolio, is to introduce you to, and to inform you of, the wonderful photographic opportunities out there.

This book will be especially useful for the photographer visiting either Kenya or Tanzania, although in many cases the information is equally valid for photographing wildlife in other areas of Africa. The game in Kenya and Tanzania is very similar, and in many ways the two countries differ only in their politics. And, southern Africa shares many of the same species of mammals as East Africa. Most of

my safaris, however, have been to Kenya, as the road infrastructure and the reliability of the drivers there result in efficient, productive trips. But whichever country you visit, be it eastern or southern Africa, your safari will be one of the highlights of your life.

Most assuredly, this is not a general guidebook to East Africa or its wildlife, or to its many national parks. There are plenty of great books available on these subjects, ranging from those covering countries, national parks, wildlife, and safari topics, to the innumerable natural history books on specific animals or animal groups. These books are invaluable for in-depth information on their particular topics, but they don't address the specific needs of serious wildlife photographers.

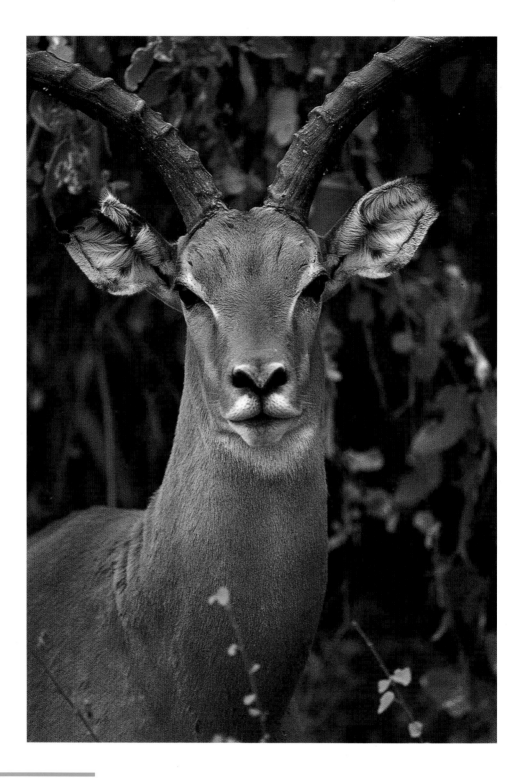

My objective in writing this book is to provide you, the photographer, with the information you'll need to select the right type of safari, to equip you properly, and most importantly, to alert you to the photographic possibilities with the animals and birds you'll see. To me, this last concern is the most important, since knowing and being ready for what an animal may do will markedly increase your chances of capturing exciting images.

Note that in my captions I don't list the reserves or parks where I took those images unless this data is very relevant. Too often, photographers subconsciously gravitate to known "hot spots" with the hope or expectation of duplicating, or surpassing, images they've seen. This would be very counterproductive in Africa because there are so many great parks, offering so much opportunity—it would be silly to follow exactly in my path. And, to be sure, despite this abundance of animals, I've yet to film many of the things I've seen and written about, but that's part of the fun and challenge of photographing wildlife. If it was really simple, would it be worth it?

Still, this book will make it much easier for you to capture outstanding images. By knowing what to expect, and what you're likely to see if you're patient and have a bit of luck, you'll return from your African safaris with the type of photographs that do justice to this magnificent land.

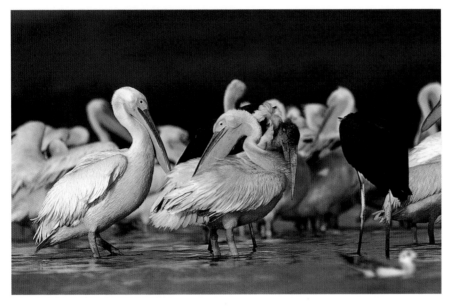

AFRICAN WHITE PELICAN
500mm F4 lens, 1/250 sec. at f/5.6, Kodachrome 64.

I lay on my belly to shoot this flock of birds at water level. Doing so presented some problems, not just in the mess I made of my clothes, but also in trying to keep my camera level with the water's surface. As you can see, I wasn't totally successful.

IMPALA BUCK
500mm F4 lens, 1/250 sec. at f/8, Kodachrome 200 at ISO 250.

Of all the antelopes, the impala is among the most attractive. This handsome buck was standing so close to a thick bush that a full-body shot looked too busy. Instead, I used my longest lens and made a tight portrait, thereby eliminating the potential distractions.

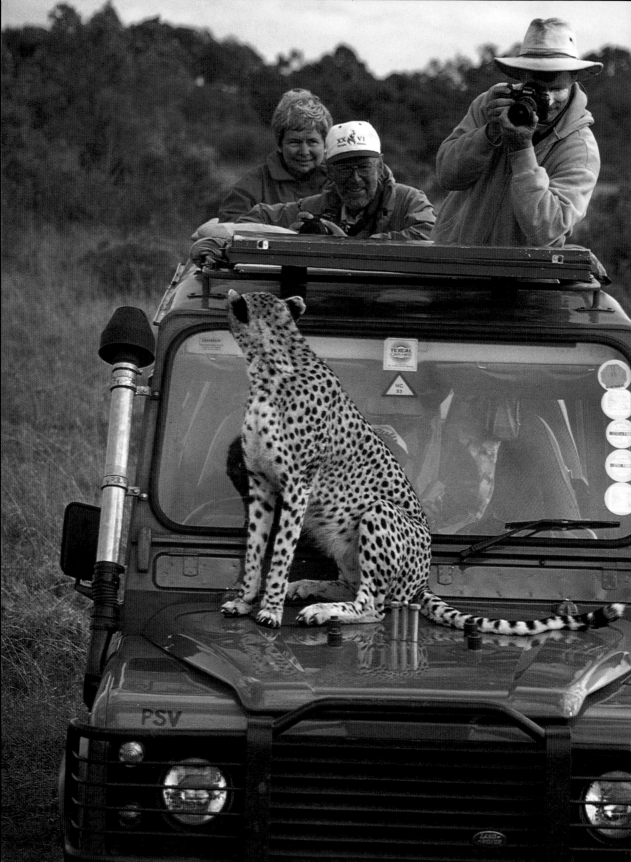

Choosing Your Safari

SAFARIS VARY GREATLY, not only in terms of price, but in duration, itinerary, and, most importantly, focus. If you're a casual photographer going on a safari as a vacation, and you're interested as much in fine food and pool time as you are in photography, a real photo safari may not be for you. If you're a more serious photographer, then a safari emphasizing a lot of camp or recreational time and fine dining may be frustrating. Photographers should look for photo safaris, although even under this category, there are a wide variety of choices and value offered by tours in East Africa.

CHEETAH AND LAND ROVER
Masai Mara Game Reserve, Kenya.
(Photo by Ivan Rothman.)

On several occasions, I've seen cheetahs use the hood of other vehicles as hunting lookouts, but only once has a cat used my Land Rover as its base.

The various itineraries alone present a mind-numbing amount of options, covering a vast range in prices. For many, the price is the defining factor, and few safaris are relatively inexpensive; most represent a sizable outlay of cash. Knowing where to look and, more importantly, what to look for among the countless offerings can be daunting, but making the correct choice is critical if you wish to make quality photographs. The least expensive safaris are general, nature-viewing trips that might appeal to first-timers, tourists, or those with only a very moderate interest in wildlife or photography. Prices for these differ depending on the tour operator, the number of people on the tour group and in each vehicle, the itinerary, the mode of transport from park to park, and the accommodations therein.

Unless you're particularly adventuresome, on a tight budget, or only marginally interested in photography, I'd steer clear of discount trip packages in

Although difficult to describe, the thrill of seeing wild game is universal.

which you tour parks via open truck or lorry and set up camps nightly. These tours may be fine for moderate nature- and game-viewing outings, usually under dusty conditions, but anyone seriously interested in making photographs will likely go mad. The same might be said for another option—birding safaris. These certainly will appeal to anyone interested in adding more bird species to their sighting lists, but generally, bird-watchers and photographers do not mix well. While birders require frequent short stops to identify a seemingly endless supply of new birds, photographers need time to wait for action or for the right light.

Readers of this book should look for a safari specifically designed for folks who are seriously interested in taking photographs. A good one will also incorporate great nature-viewing and bird-watching with your shooting. Indeed, all safari types should be combined a little bit; the birds are simply too good to pass up. In general, making successful images demands quality time spent in either observing or patiently waiting for wildlife, and this affords you great opportunities to really experience and appreciate your subjects.

Vendors, travel agencies, safari-tour operators, and individual photographers advertise in the back of many national magazines. As a general rule, photographic safaris advertise in photography publications, such as *Outdoor Photographer* or *Nature Photographer*, while general nature safaris advertise in magazines that have a broader readership, such as *Wildlife Conservation* or *Natural History*. You're more likely to find a good photo safari in a specialist, rather than a general-interest, magazine.

Photographic safaris are usually more expensive than other safaris because there are, or at least there should be, fewer passengers per vehicle. Many tours advertise a window seat for everyone, but that's a meaningless point if there are seven photographers all trying to squeeze a shot out of one side of a van or shoehorn their way through a roof hatch. A good, reasonably priced photo safari should have no more than four passengers per vehicle, or less if possible; three photographers, plus the driver, per vehicle allows for ample room for shooting and equipment.

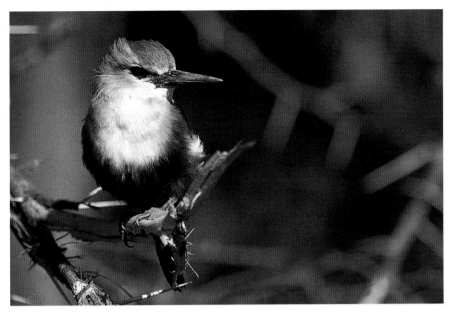

Several species of kingfishers are common along water holes, where they hunt fish, insects, or small reptiles.

BROWN-HOODED KINGFISHER
500mm F4 lens, 1/250 sec. at f/5.6, Kodachrome 64.

Deciding on an Itinerary

It is tempting to book a safari that visits several different locations, especially if it is your first trip and you're hoping to see everything. You might assume that picking a tour that covers a lot of territory would increase your chances of seeing the greatest variety of animals and birds, but the reverse is often true. Visiting fewer parks means that you will spend more time actually photographing, and waste less in commuting. This is an extremely valid point when you consider the size of these countries: Kenya is approximately the size of Texas, and Tanzania is over 1 1/2 times that.

Quality shooting, in which you're not restricted to the token image of a pride of sleeping lions because you've no time to wait for action, is impossible on a busy, park-filled schedule. A safari that visits more than five parks in only two weeks afield will leave very little time for photography. It has been my experience that with enough field time in just two or three parks, you'll see as many species, if not more, as you would hopping from one supposed "hot spot" to another looking for each park's particular specialties. Dis-

tances on a map are deceptive because travel by road is excruciatingly slow. A 200-kilometer trip may take four, six, or even more hours, and roads are often pot-hole-ridden and quite uncomfortable at any speed.

Some safaris offer flights between parks, and this eliminates the ground-travel problems but does pose some others. In-country flights limit luggage, with some airlines being so restrictive that a serious photographer's camera bag alone could exceed the baggage allowance—forget about carrying film or a change of clothes! If you want to save time and wear and tear, a better alternative is to fly from park to park while transporting your luggage and gear by ground vehicle. In this way, you'd probably have the same driver on all your safari game drives (he'll drive your luggage while you fly). This is a real plus because you're likely to have a more enjoyable time with a driver who is with you throughout your entire trip (and is interested in a nice gratuity at its end) than you would with a safari-lodge or -camp driver who you may only see for a few days. Of course, a flying/driving safari is, as you'd expect, quite expensive.

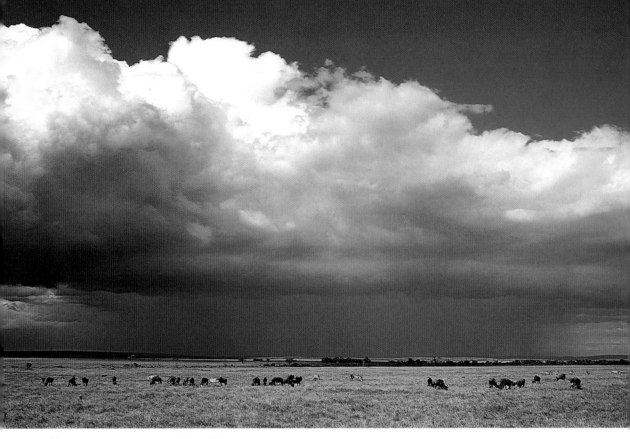

THUNDERSTORM OVER THE MASAI MARA
28–85mm F3.5–4.5 zoom lens, 1/60 sec. at f/11, Fuji Velvia 50 at ISO 40.

It is important that you choose a safari that encompasses the seasonal activity you're interested in seeing. If you enjoy landscapes and spectacular cloud formations, nothing beats the short, rainy season in either Kenya or Tanzania.

When Should You Go?

Situated close to the equator, Kenya and Tanzania aren't characterized or defined by radical temperature changes, but by dry and rainy seasons. Both countries have a short rainy period lasting from October through December and another rainy spell from March through May. Prices are less (sometimes considerably so) during the rainy seasons, but a photo safari at this time of year can be a complete bust. The seasons also govern any flexibility in your accommodations. For example, many camps and lodges limit the number of single rooms available to a bare minimum during peak season, the dry summer months from July through September. At that time, tourists traveling alone, and paying for a single supplement, may find that they're still sharing a room at some of the more popular, and frequently overbooked, camps and lodges. Worse, on occasion some less scrupulous lodges will completely overbook, and latecomers can find their first night's accommodations reduced to a few rooms, requiring doubling or tripling up. Off-season, these concerns are minimal.

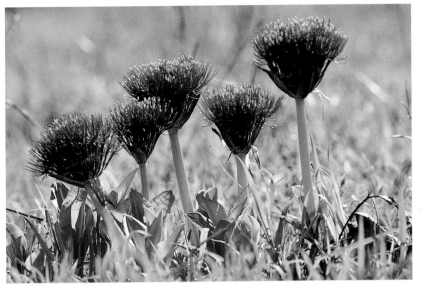

FIREBALL LILIES
200mm F4 lens, 1/30 sec. at f/11, Fuji Velvia 50 at ISO 40.

During the rainy seasons, deserts and grasslands erupt with the colors of new growth and flowers. Each of these lily heads is about the size of a tennis ball.

THOMPSON'S
GAZELLE BABY
600mm F4 lens, 1/125 sec. at f/4, Kodachrome 200 at ISO 250.

To get this ground-level shot and yet not frighten the gazelle, I climbed out of my vehicle on the side facing away from the gazelle, got into position on the ground, and then had the driver back up just enough so that I had a clear view. After making a few shots, he drove in front of me again, and I climbed back inside the vehicle. The gazelle never stirred.

The seasons certainly define animal activity. If you're interested in a particular event, such as the mass birthing of wildebeests on Tanzania's Serengeti Plain, the time of your safari is crucial. It is important to know what to expect at the parks your safari will visit, and your travel agent or tour leaders should be able to provide that information. If they can't, you may be looking at the wrong safari.

Since many photographers consider Kenya's Masai Mara Game Reserve to be one of the premiere wildlife locales in Africa, and since the Mara's activity is among the most predictable in the area, let's consider the effects of this park's seasonal changes on photographic opportunities. During the long, dry season, which runs from July through September, vast herds of gnus migrate into the Masai Mara from the Serengeti Plain. In these months, hundreds of thousands, or perhaps even millions, of gnus dot the Mara's yellowed grasslands in a scene that is probably reminiscent of America's huge bison herds of the last century. River crossings involving thousands of gnus often take place along the Mara river. On most mornings, there is plenty of action involving hyenas and lions that have killed during the night. By late September, most of the gnus leave the Mara, traveling southward into the Serengeti where, in February, 90 percent of the pregnant gnus calve within a three-week period.

In some years, this migration into the Mara occurs late in the season or not at all, although normally it coincides with Kenya's peak tourist season. Those travelers hoping for a private commune with nature may be sorely disappointed at this time because many camps are booked full with professional photographers and tour groups. As a result, shooting around a well-known cheetah family becomes an exercise in frustration and diplomacy as photographer-filled vehicles compete for the best shooting locations. Fortunately, off-season trips can be very productive for photography, especially after mid-September when the summer crowds leave.

The Mara's short rainy season begins in November and is characterized by afternoon or evening thunderstorms. Mornings, and sometimes entire days, can be cloudless, or at least rain-free. The veg-etation is green and lush, and the grasslands are dotted with flowers. Cloudscapes are at their best, and scenic potential is great, too. And, dust—normally the plague of dry-season game tracks and roads—is less bothersome.

During the late December-to-February dry season, there are many young about. The vast grasslands of the lower Mara seem empty, because the gnus and most zebras have already migrated to Tanzania. Prey becomes increasingly scarce as the season progresses, and by February, lions are desperate for food and regularly hunt large animals such as giraffes and African buffaloes. Resident hyenas also actively compete with other predators for kills.

From March to May the long rains occur, and roads and game tracks are impassable for the normal two-wheel drive safari van. Four-wheel drive travel is possible in some areas, but you may have to curtail the shooting day due to the low light and wet weather. By June, the long rains are over, and the Mara's grasses are high, making game-viewing difficult in some areas. The first gnus may enter the lower portions of the park, beginning another massive, but unpredictable, migration.

Other parks, of course, offer different schedules with their wildlife, weather, and shooting opportunities. If the time of your visit is inflexible, don't despair—with the vast number of parks available, you can hardly go wrong.

Private Safaris versus Tours

A private safari can run from a luxury affair with camps set up exclusively for your party, to merely a personal driver who pilots you through the country while you stay in permanent camps or lodges. The former, obviously involving a host of logistics, can be extremely expensive. The latter might only cost a bit more than a traditional tour.

Ideally, a private safari should provide you with the opportunity to spend as much time as you wish on your game drives or with a particular animal. I say "should" because your driver/guide might dictate your schedule, especially if it is your first trip. Although most guides are conscientious, it is possible

that you could have a driver/guide who tries to cut corners and work as little as he can. This attitude isn't always obvious. Some guides create wonderful excuses that sound plausible but are designed only to shorten their work day. It can be difficult to know what's really going on.

Whether you're on a private safari or a tour, I think it is quite advantageous to travel with more than one vehicle. This way there's always the insurance that, if one vehicle breaks down, you have a backup and can still make a game drive, or at least continue to your next camp, while the other vehicle is repaired or replaced. If you're traveling with a small group, using two or more vehicles gives you a chance to rotate your shooting partners, and this can provide needed relief during a two- or three-week trip. This is very important, especially in stressful circumstances—and they will occur. Perhaps, most importantly, a multiple-vehicle safari increases your odds of spotting elusive subjects because you can cover more area with two or more vehicles, provided your drivers don't follow each other like a train.

Tours are prepackaged, and a group leader (or driver/guide if it is an unaccompanied tour) might dictate time schedules, itineraries, and shooting hours. Tours might use private camps that are set up exclusively for a group, but most use permanent camps and lodges. Many use more than one vehicle, and good tours, composed of a group with similar interests, can be a lot of fun and quite productive photographically.

Permanent Camps, Lodges, and Tented Camps

Accommodations should play only a minor role in choosing your trip. Granted, there's a wonderful ambiance to rustic tented camps erected for a small, personal safari, but when you consider that you're there to photograph, the camp environment is of lesser importance. First-timers are often surprised by the quality of the accommodations on safari. Images of "darkest" Africa, or perhaps personal flashbacks from nightmarish camping trips, conjure up bleak expectations, but for the most part, safari camps, tents, and lodges are all extremely comfortable.

As their name implies, permanent camps and lodges are fixed, stationary accommodations. Large tourist lodges can sleep well over 100 people and usually have a full range of features, from gift shops to fully stocked bars. Buildings support electrical generation, hot water, food preparation, a bar, and tourist quarters. Rooms are comfortable; some resemble American or European motel rooms, but more often, they are private bungalows of sturdy canvas and a thick thatch roof. All have private baths and showers, and a comfortable bed or cot. Some can be luxurious in their amenities, including four-poster beds, china, and linen tablecloths. Services differ, of course, and many small camps rival even the largest lodges in their facilities.

On camping safaris, tents are set up as the group travels from one location to another. Low-budget safaris may require that participants erect their own tents and help with the campground chores, while on the more costly camping safaris, the staff precedes the tour and sets up camp. Both types provide a sense of adventure and a feeling—of seeing the "real" Africa—that's lacking at a permanent camp.

The comforts of a tented camp are clearly more limited. One or more communal, portable-type chemical toilets replace private bathrooms and flushing toilets. Hot showers may only be available at

Dessert table at a safari lodge.

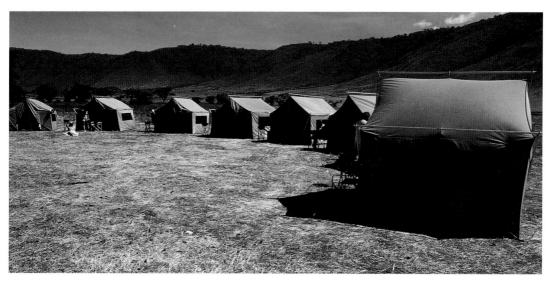

TENTED CAMP IN TANZANIA

*Small tented camps provide the ambiance one expects in the African bush. As it is not unusual
for a lion to walk through camp in the middle of the night, sleepwalkers should beware!*

midday, when the sun warms the water bags, or at
the day's end, when the camp heats the water with
fire. This rustic camping appeals to some, but it can
be taxing, especially in bad weather. Tenting for days
on end during a prolonged wet spell can become a
dull, chilling experience, especially for a first-timer
who isn't accustomed to the rigors of camping.

The size of a camp or lodge is not as critical to
your safari as its location. You should consider
whether you are in a prime game-viewing area, or at
least within an easy commute. Some camps aren't,
and you might not want to be a half-hour drive from
a park or reserve border. Ideally, the game should be
right outside your camp or lodge so that you can film
in the magic light of dawn and dusk. This is espe-
cially relevant because most parks require tourist ve-
hicles to be inside the lodges or camps, or outside
the park borders, between sunset and sunrise. How-
ever, this restriction won't always apply or affect your
activity. For example, the lodges located outside the
Masai Mara's park boundaries aren't held to this rul-
ing; there, you can leave long before dawn and re-
turn after sunset, because you're out of park jurisdic-

tion (but still in the heart of great game country).

Also keep in mind that if crowds bother you and
you relish quiet experiences, a small, private, tented
camp is probably for you. If you're more concerned
with economy or an ideal base-camp location, then
a larger, tourist camp may fit the bill for you.

Another option is a tree lodge. I rarely visit these
camps, where most visitors stay for one night to
watch the animals at the illuminated water holes.
The conditions are okay for viewing game, but are
fairly poor for making quality photography. But,
since most people stay for only one night, the lodges
are practically deserted at midday (between the time
one group of tourists checks out and the next ar-
rives); so, if there's a maintained bird-feeding station,
ground-level blind, or other hidden observation area
near a water hole, you're likely to have the place to
yourself throughout the afternoon.

If you're adventurous, or are trying to save money,
you might consider driving your own vehicle and
camping. Most parks have camping areas. Some of
these are close to park gates, with nearby park
guards; some are near villages. Others are more re-

mote. Camping can be risky; poverty and unemployment are common in Kenya and Tanzania, and desperate criminals are out there. The worst horror stories I've heard involved campers. I wouldn't recommend this route.

How Long Should You Stay?

Veteran safarigoers—those who return year after year—know that any trip is too short a time to see it all. However, financial considerations aside, I find that many serious photographers are mentally, and sometimes physically, exhausted after two weeks of intense shooting. A safari that includes two to three weeks of field time will fit the needs of most.

Almost all parks have enough shooting potential to require a visit of at least three nights. This should provide two full days of game drives and perhaps two additional half-days (on the afternoon of your arrival day and the morning of your departure day). You might find it helpful to consider the following basic safari schedules.

On an 18-day trip to Kenya, you lose two or three days to air travel, spend another in Nairobi, and essentially lose yet another two days in ground travel. This leaves 13 days to spend afield. An itinerary that covers four parks during that period should provide ample shooting time at most locations.

In Tanzania, park infrastructure and game movement dictate itineraries. For example, just a few years ago you were permitted to camp inside the crater floor of the famous Ngorongoro Crater. From this base camp, game drives started shortly after sun-

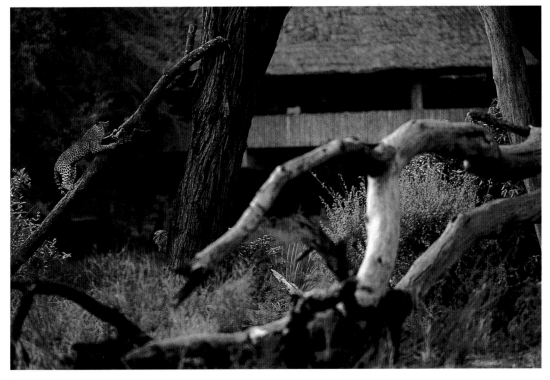

LEOPARD TAKING BAIT AT A LODGE

Some lodges place baits out for leopards, and other nocturnal predators, giving most people their only chance at seeing leopards, striped hyenas, ratels, civets, and small genet cats.

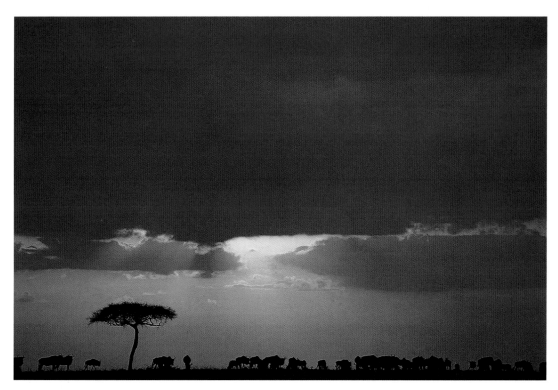

SUNRISE SILHOUETTES AND GNU MIGRATION
300mm F2.8 lens, 1/250 sec. at f/5.6, Kodachrome 64.

It is important to realize the limitations of your film when you're shooting silhouettes. I purposely positioned the gnus and land very low within the frame, because I knew there wouldn't be any visible detail below them; I metered the bright area below the sunbeams and overexposed off that reading by one stop.

rise and then again in late afternoon. Safarigoers spent midday lounging in camp to avoid the high, harsh light. Now that camping is prohibited in the crater, tourists must use the lodges that line the crater's rim. From this location you have to commute daily to the crater floor, which wastes time. Since game viewing is best in the hours around dawn and dusk, and since the light is the worst during midday, this system reduces the amount of quality photography time per day. Consequently, you might need a longer stay around Ngorongoro.

Also in Tanzania, Serengeti National Park is spectacularly beautiful in its primal expanse, and can be especially rewarding around permanent water areas. In the grasslands, however, game viewing can be difficult because many herbivores inhabit the plain for only a portion of the year. When there are millions of gnus present, some areas teem with life, but when the herds migrate north toward Kenya, the grasslands can be virtually barren. Even when the herds are present, they might be anywhere in this vast 3.6 million-acre area, and some visitors leave disappointed by the lack of animals.

In deciding on the length of your stay at any park, you must consider both your interests and your boredom level. If you're the type who could spend one

day in the Everglades or Yellowstone and feel you've seen all that you needed to, then three to five days per park in Africa would probably be too long for you. Conversely, if you're a patient photographer who sees opportunities everywhere, then it is quite possible that you could happily spend an entire trip within the boundaries of a single park. Although I'm the latter type, I still divide my time between four areas to maximize my chances of success and enjoy the variety that several locations provide.

Vehicular Concerns

You might not have a choice of vehicle because your safari company might have its own fleet. Most tourist groups use either two-wheel drive vans or four-wheel drive Land Rovers (or Toyota Land Cruisers), and there are advantages and disadvantages to both.

The van is the typical tourist vehicle and can seat nine or 10 passengers, plus a driver. Some safaris advertise "window seats" for everyone, and this translates to seven people all crammed into one vehicle

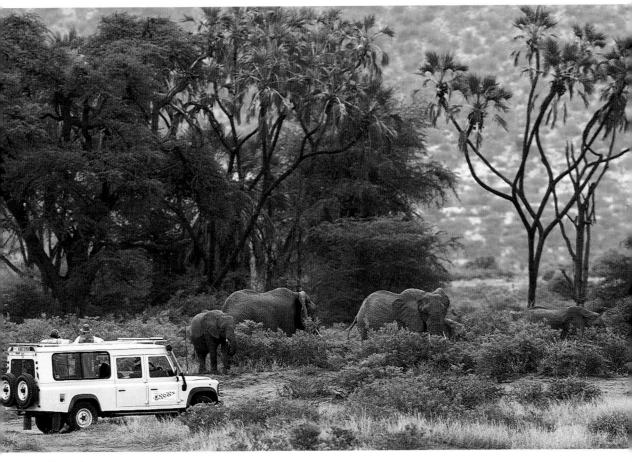

LAND ROVER AND ELEPHANTS

I've used both Land Rover vehicles and Nissan vans on safari. You're less likely to get stuck in the mud with four-wheel drive vehicles such as the Land Rover, although it has happened to us.

and squashed against the windows. Most safari vans have open roof hatches, either pop-ups that raise up like elevated roofs, or completely detachable roof covers. A pop-up usually has one large opening that every passenger can fit into, while the open roof type may or may not have separate compartments that divide the hatch into sections. I prefer a van with a single port, especially if there are only a few people inside; a large opening provides the freedom to move about, from front to rear if necessary, that a divided hatch does not. On the other hand, pop-up roofed vans are extremely comfortable, too, because they provide shade under a high, hot sun.

Most vans are Japanese-made Nissans, which are sturdy, reliable forms of transportation that can take a real beating. Almost all of these are two-wheel drive, but the skilled driver/guides blithely negotiate countryside that most Americans would avoid even in four-wheel drive vehicles. Still, as a two-wheel drive vehicle, vans are more likely to get stuck in muck or swampy soil than are four-wheel drive vehicles.

Most of the four-wheel drive vehicles that you'll encounter on safari are British-made Land Rovers or Japanese-made Toyota Land Cruisers, although for simplicity I'll refer to both as Land Rovers here. Both have open tops, which are always uncovered, and can be quite hot during the midday sun. Land Rovers are a bit more cramped than vans, and it is much harder to move from front to back in them than it is in a van. As I said, however, four-wheel drive vehicles are less likely to get stuck.

While photographic safaris usually limit the number of passengers per vehicle, this is absolutely critical if you are using Land Rovers. If necessary, four photographers could shoot from the windows and open hatch of a Nissan van, but in the tighter quarters of a Land Rover, this would be very uncomfortable.

Safarigoers who drive themselves typically use four-wheel drive Suzuki jeeps. These short vehicles are reliable and provide good shooting opportunities through both the front windows and the roof hatch. There's certainly a sense of adventure in driving one's own vehicle. On the negative side, there are the wor-ries of breaking down, or getting lost or stuck. Additionally, it is difficult for one person to drive, spot game, and take photographs. I've found that I see and photograph far more animals during my group safaris than when I drive myself. For my money, I'll choose taking a driver over driving myself any day. Of course, I'm talking about a driver who knows the roads and country; it will do you little good to know that there's a leopard eating an antelope in Kissinger's Tree, if your driver doesn't know where that famous landmark is. (It is said that Henry Kissinger saw a leopard at this spot on a safari in the Masai Mara.)

I think it is important to note that I took every wildlife photograph in this book (with the exception of the wild dogs) on photo safaris that I led, and while sharing a vehicle with either two or three other photographers.

Alternative Excursions

You may have the opportunity to book some less-traditional adventures while on safari, and although they might not necessarily be photographically productive, all are interesting.

Most walking safaris are short or moderate hikes of a mile or two led by a local guide, who's based at a game lodge. Some tour organizers offer entire safaris on foot. Walking safaris provide a novel viewing perspective—to see game with an intimacy not possible in a vehicle; they are not, however, a productive way to photograph wildlife, since most game animals keep their distance—they are far more wary of a person on foot than they are of a vehicle.

Night drives are also available at a few of the camps on private ranches. The wildlife of the African night is quite different from that of the day. You almost never see kangaroolike springhares, ant-eating aardvarks, or insectivorous aardwolves during daylight hours. At one time, night drives were legal outside some of the largest game reserves, such as the Masai Mara, but concern over poaching eventually resulted in the outlawing of that practice. I've only been on one night drive, and I'm not a big fan of them; although I saw a few species that I missed during the day (and had an exciting, blink-of-an-eye

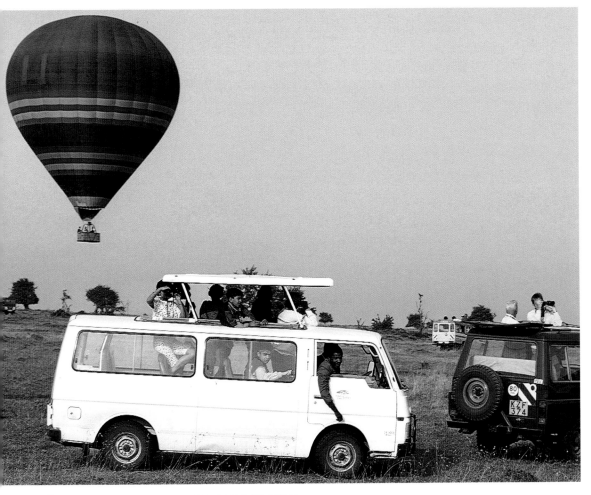

SAFARI VANS WITH HOT-AIR BALLOON IN THE DISTANCE

Whether by land or by air, you have the option of enjoying the wildlife and landscape from several perspectives, including from a balloon.

glimpse of a leopard grabbing a dik-dik), I couldn't photograph anything well.

Ballooning is, perhaps, the most popular alternative activity. In the Masai Mara, several camps offer balloon rides, complete with a champagne breakfast upon landing. If you've never taken a balloon ride, I honestly can't think of a better place to do one.

Ballooning is a bit controversial, however. Some naturalists and tourists object to the gaudy balloons dotting the sky of the unspoiled African landscape. Others worry that the roar of the balloons' propane tanks frightens game. Conversely, many people enjoy the colorful balloons and feel that animals are probably oblivious to the sound of their jets. In 1995, a balloon trip cost between 300 and 400 dollars, but you can negotiate the price on slow, off-season days.

The quality of your photography from a balloon depends on how many people share the basket and

MAASAI VILLAGE

Taking photographs, such as this one, from a tiny microflight is exciting but difficult to do in the craft's open cockpit. Using an autofocus lens and setting your camera on shutter-priority helps, since it is difficult to look through the viewfinder with tear-filled, wind-blasted eyes.

the skill and enthusiasm of your pilot. Some balloons can take 8 to 12 passengers, and at peak capacity, you won't have much room to maneuver. A good pilot will base the altitude of the balloon on the subjects below; a poor pilot won't.

Another variable is the length of the ride, and this depends on the winds. On a very still, windless morning, a ride can last for well over an hour. If the wind kicks up, the ride will end sooner, and the landing can be rough, or even dangerous, because the partially collapsed balloon acts like a sail, dragging the basket across the grasslands.

In general, it is easy to shoot basic aerial animal images and scenics (landscapes) from a balloon. Game trails snaking across the grasslands, clusters of hippopotamus pods in rivers, and individual or herds of animals are typical subjects. Zoom lenses covering focal lengths of 35–70mm and 75–300mm work well. For all you Canon owners, Canon's all-purpose 35–350mm zoom is the perfect lens for ballooning.

An adventuresome alternative to a balloon ride is a microflight. Part hang glider, part plane, the delta-wing craft is powered by an engine that seems barely larger than a hefty lawn mower. The passenger sits in a tiny seat behind the pilot, with legs straddling the pilot's shoulders. Since there's no cockpit, your face and eyes are constantly buffeted by wind, and you might have to land each time you need to change film or lenses because anything that drops might fly into the propeller, causing major problems.

Despite these conditions, I enjoy microflights immensely because of the sense of adventure. I was wind-blown and blind much of the time, and my eyes teared constantly, but I had some clear moments. And, unlike ballooning, in which you travel in only one direction, on a microflight, we could circle and return to a spot repeatedly if I wished. It is possible, but not easy, to make great images on a microflight, and it certainly involves more risk than a balloon ride.

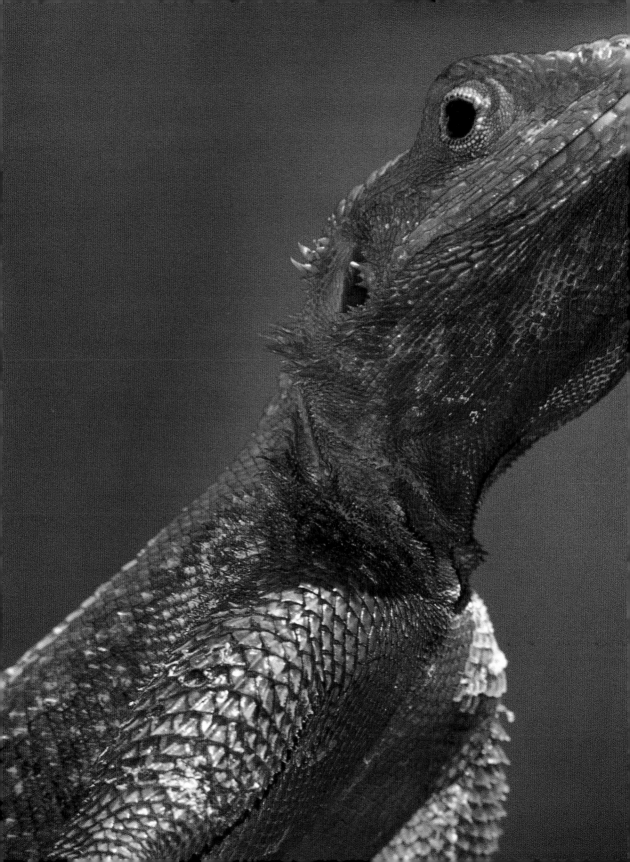

Camera Equipment and Film

ON SAFARI, I photograph the same variety of subjects that I do at home. While I certainly concentrate on wildlife, I also photograph scenics, macro subjects (close-ups of small subjects, such as lizards and insects), and human portraits using both ambient light and flash, and my equipment always reflects this diversity. And although my gadget bag contains much of the same gear as it usually does, it is oftentimes much lighter because I try to slim down to the bare essentials when I travel.

AGAMA LIZARD
200mm F4 lens, 1/60 sec. at f/11 with TTL fill flash, Fuji Velvia 50 at ISO 40.

This large male agama lizard was accustomed to people, so it was easy to get close to him for a tight portrait. I based my exposure upon the ambient light, then dialed in an exposure compensation of -1 on my TTL flash to fill in the harsh midday shadows.

I mention this because many photographers bring along far more equipment than they need or will use in a two- or three-week period. A safari is a once-in-a-lifetime experience for many, and there's always a tendency to overpack. Certainly, there are some essentials you must carry that may be new to you, especially if you're photographing wildlife for the first time, but for the most part, your gear should reflect your usual shooting interests. Of course, photographers' gadget bags will differ as greatly as their shooting styles, and I hope you'll keep this in mind as you consider my suggestions. You can use fewer lenses or more filters than I suggest, and you should be able to judge what you'll need based on the explanations that follow.

Cameras

On all my trips, I follow one unwavering rule: Without exception, always carry at least one backup camera in case your principal camera breaks down, and always carry that spare with you on every game drive. Nothing could be more demoralizing than to be cameraless on the trip of a lifetime or "the photographic event" of a safari.

Your backup camera should be the same brand as the camera you normally use. It does little good to carry a spare Nikon if you usually shoot with Canon equipment, unless you have a full set of compatible lenses to support this second system. The spare camera need not be the same model as your regular one, however; for example, although I often shoot with a Nikon F4, I carry the lighter, less expensive N90S or 8008S as my backups. In doing so, I cover myself without going too deeply into debt. Make sure you acquaint yourself with the basic operation of your backup camera before you go, in case you need to use it on your trip. On safari is not the time to learn a camera's operation.

Besides providing the security and insurance of a spare, a second camera body is often useful in expediting your shooting. I frequently keep two or three cameras at the ready when I'm on a game drive. I mount one camera to my longest telephoto lens, either a 500mm or 600mm, another to my favorite lens, a 300mm F2.8, and a third camera to either an 80–200mm or a 35–70mm zoom lens. In this way, I'm ready for whatever shooting opportunities arise.

Unlike in some exotic destinations where extreme cold or humidity may dictate camera selections, temperature isn't a problem in East Africa. The climate and shooting conditions differ little from what you might expect in American national parks or even around your home. If your cameras operate well there, they'll do fine on safari.

There are a few camera concerns that you should be aware of, however. Batteries are in short supply in

WHITE-BACKED VULTURE IN FLIGHT
300mm F2.8 lens, 1/500 sec. at f/8, Fujichrome 100.

For this vulture image, we positioned our vehicle ahead of the birds so that they would be flying directly toward us.

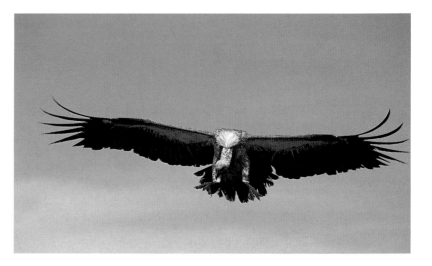

Africa, so bring more than you think you could possibly use. Shooting days are long, often running 6 to 10 hours a day, and you'll go through far more batteries than you usually do at home. If you run out, you might be hard-pressed to find replacements. Some lodges sell AA batteries, but these may have been sitting on a shelf for months. For lithium batteries, or other similarly unusual kinds, you'll be lucky to find any at all, even in the larger cities. Don't worry about overstocking and carrying spares home at the end of your trip—your driver or someone in the camps will appreciate them for radios.

Another concern is dust. Although some cameras are better sealed from moisture or dust than others, I'd recommend taking the following basic precautions when traveling through dusty areas, as well as between shooting stops on your game drives. Keep your cameras and lenses covered, either in a case or inside a plastic bag. For my long lenses, I generally use large, soft Domke lens cases when afield; I wrap the case straps over a seat back, and this keeps the lens and camera upright and within quick reach. When changing lenses, keep the camera body facing down; never set your camera down with the mirror exposed and facing upward because dust or grit may settle onto either the mirror or focusing screen. This can be very difficult to remove in the field. If you do get dust in these places, and if gentle air pressure from a blower-brush doesn't clean them, let it go until you return home and can have your gear professionally cleaned.

Motor Drives and Power Winders

Most modern electronic cameras have a built-in film-advance system, which advances the frames and cocks the shutter at a rate of somewhere between two and six frames-per-second. Motor drives accomplish this task more quickly than power winders and are generally an accessory item. Power winders usually are built-in as the standard film-advance system on cameras. The difference between the two is slight, and either one is sufficient.

The advantage in using either of these functions is, obviously, that you'll have a higher likelihood of

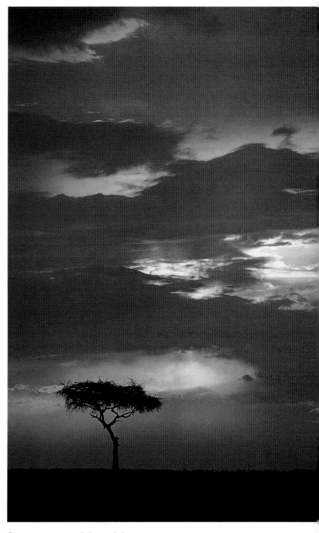

SUNSET IN THE MASAI MARA
75–300mm F4.5–5.6 zoom lens, 1/125 sec. at f/16, Kodachrome 64.

By composing in a vertical format, I was able to include the attractive dark and light pattern of the sky.

capturing a series of events when your film-advancing can keep pace with the action. Notice, however, that I didn't say you'll capture the "peak" action, as this could occur between shots. Consider the following: If you're using a shutter speed of 1/1000 of a second with a motor drive that fires at five frames-per-second, you're really only capturing 5/1000 or 1/200 of a second's activities. What's happening in the other 995/1000 of a second? Possibly, a lot. So, it is best to time your shots to try to capture peak action *as you see it*, using your motor drive or power winder to advance the film quickly so that you're ready for each shot. Don't just rely on the camera to provide blanket coverage of everything. It won't.

I use my motor drives and winders as "fast thumbs" that cock the shutter and advance the film far more quickly than I could with a camera that has a manual film advance. Additionally, I can advance frames without my eye leaving the viewfinder—something that's difficult to do with a manual-advance camera.

If you're using an older camera with a manual film advance and you're thinking of buying a second camera, consider upgrading to a model that uses a built-in power winder or an accessory motor drive. When you're shooting wildlife, you'll be glad you did.

Lenses

I'm a bit annoyed by the lens suggestions that some photographers occasionally offer for safari photography. I once read of a photographer who shot an entire safari using a point-and-shoot camera, with only a 35mm lens, to prove how little equipment is needed. That's fine if you only want to shoot wildlife scenics, but you'll need larger lenses to make portraits or capture interesting details of your animal subjects. Likewise, another person recommended a 300mm as the ideal lens for a particular park; luckily, I had *twice* that focal length with me when I was there, and I could have used more. Just as you can never be too rich or too thin, you can also never have too much focal length at your disposal.

Fortunately, you can indeed film most of the mammals in East-African parks with a 300mm lens.

Offering 6x magnification (that's six times larger than what you see with the naked eye), this lens is sufficient for full-body portraits of most species within 10 and 30 yards of your vehicle. Tighter shots, which frame an animal's face or head, often require the use of either a longer lens or a teleconverter, which is a special accessory that fits between the camera body and the regular lens and extends, or multiplies, the lens' magnification. Teleconverters are sometimes called extenders or multipliers for this reason.

For dramatic portraits of mammals and most birds, I recommend using either 500mm or 600mm telephoto lenses, which are designed to produce large image sizes. You'll get approximately 10x and 12x magnification respectively with these. Of the two, the 500mm lens is probably the better choice because while it essentially offers 10x magnification, instead of the 12x of a 600mm, it weighs considerably less. Canon's 500mm F4.5 autofocus lens and Nikon's 500mm F4 manual lens each weigh about as much as their respective 300mm F2.8s. Their 600mm lenses, in contrast, are real whoppers and take two hands to operate. I'd only suggest packing a 600mm for those who are sure they can manage the weight of these monsters.

If you're on a more limited budget and wish to increase your focal length without buying numerous lenses, consider using a teleconverter. As I said above, a teleconverter multiplies your lens by a given factor. For example, a 1.4x teleconverter would "convert" a 300mm into a 420mm lens. A 2x converter can double a 300mm lens' focal length to 600mm. This convenience does come at a cost, however, and this is in light loss. You'll lose one stop of light with a 1.4x and two stops of light with a 2x model. "Stops" (F2.8, F4, F8, etc.) refer to the lens aperture, the opening through which light passes to reach the film. Larger aperture numbers indicate smaller lens openings, which allow less light to reach the film. To compensate, you must use a slower shutter speed to provide more time for the light to reach the film, so, for example, using a 300mm F4 lens with a 1.4x converts the lens to a 420mm F5.6; with a 2x, it results in a 600mm F8. An aperture of *f*/8 is pretty slow, espe-

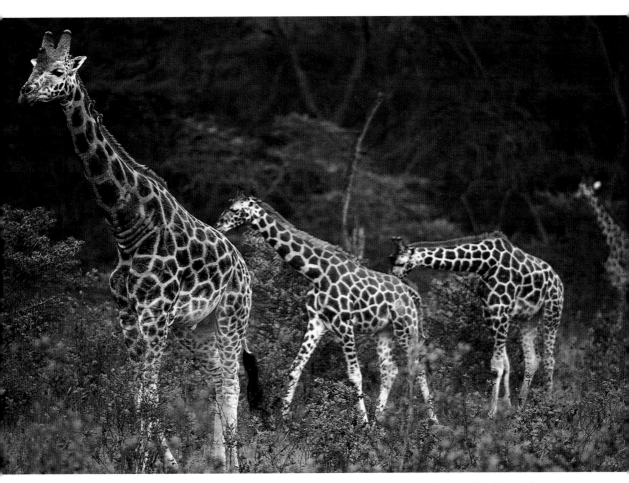

ROTHSCHILD'S GIRAFFE PARADE
80–200mm F2.8 zoom lens, 1/125 sec. at f/8,
Kodachrome 64.

You can't beat a zoom lens for compositional versatility. Since I shoot manually, I prefer fixed-aperture zooms, on which I don't have to change my exposure setting after zooming in or out.

cially with slow ISO films, in anything less than bright sunlight, and it requires a slower shutter speed. Fast shutter speeds are better for capturing action, while slow speeds may result in blurred pictures. Most 1.4x teleconverters have excellent optical quality, but I have a less enthusiastic endorsement of many 2x teleconverters. If your principal long lens accepts a 1.4x teleconverter, take one along. If you're interested in the 2x variety, I'd suggest checking one out by shooting a test roll at home before you use a bundle of film on safari. This way, you'll know if you like the results.

Zoom lenses are another alternative, especially telephoto zooms that cover a focal-length range from 75mm to 300mm or higher. These offer several different magnifications in just one lens; you can "zoom in" for a close-up or "zoom out" for a broader view. There are several lenses in this range, including zooms of 75mm to 300mm, 100mm to 300mm, 100mm to 500mm, and 200mm to 400mm. With any of these lenses, you'll have sufficient magnification for most subjects, plus the potential to make outstanding portraits of larger mammals and smaller animals that

you find up close. Many zooms accept teleconverters, but some don't, being too slow or losing their autofocus function when used with a converter.

Aside from the long lenses, you'll find plenty of use for shorter lenses, too. I recommend covering the whole focal range from 20mm, 24mm, or 35mm up to 80mm. This is quite easy to do with one or two zoom lenses that incorporate all these focal lengths. Shorter focal length lenses are great for capturing animals in their habitat, human portraits, and scenics.

On game drives, you'll have little need for a macro lens since you'll probably make most or all of

FLAP-NECKED CHAMELEON
200mm F4 macro lens, 1/30 sec. at f/11 with manual flash, Fuji Velvia 50 at ISO 40.

Although I took this photograph on basically an ambient-light exposure, I used a small amount of flash to "pop" or intensify the color a bit, and this also resulted in an eye highlight.

your shots from a vehicle. Macro lenses are special close-focusing lenses that yield life-size images of small, nearby subjects. Insects, spiders, lizards, and flowers are plentiful around the camps and lodges, and ambitious photographers could spend all of their free time with a macro lens and a tripod. Most visitors, however, use any spare time to catch a nap, clean gear, or just relax. But, if macro subjects do appeal to you, consider packing an extension tube or a double-element close-up lens instead of a true macro lens, which is much heavier.

An extension tube is a hollow, rigid extension (sometimes called a ring) that fits between your camera and lens and increases the magnification of the lens. Coupled with a 75–300mm zoom lens, a 50mm extension tube will give you a range of magnification from about 2/3 life size to about 1/6 life size, covering a working distance (the space between the front of your lens and your subject) that varies from only a few inches to several feet. A double-element close-up lens won't provide the same flexibility in working distances, but it weighs even less and will, with a medium-range zoom lens, provide an adequate magnification that approaches 1/2 to 2/3 life size. It contains two lenses, provides

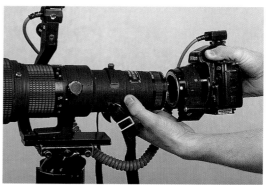

You can couple extension tubes with a variety of lenses. I often use a 50mm extension tube with my longest telephoto lenses when I'm working close to subjects such as lizards or small birds. Here, I attach a 500mm lens and an extension tube to a camera.

sharp images, and screws on to the front of your regular lens.

Personally, I prefer using extension tubes rather than double-element close-up lenses because, on occasion, I use my 300mm or 500mm telephoto lenses for distances closer than their minimum focus. Extension tubes provide greater flexibility; they work with any lens since they mount between the lens and camera, while close-up lenses will only screw onto the front of lenses of similar diameters. I can't use the close-up lenses with my long telephotos because the front diameters of the telephotos are much larger than the close-up lenses. Of course, this discussion of substitute macro-photography equipment isn't really relevant if you're like me, and you'll trade photographs for naps.

How We Pack for Travel

Since my wife, Mary Ann, and I both photograph together, we probably carry more gear than the average shooter. However, I've seen plenty of folks carrying a lot more. Be that as it may, what follows is my packing list for two photographers who'll shoot just about anything that looks good. You may want to use this as a guide in your own packing.

In my photo vest:

1 Nikon F4 camera

2 Nikon N90S cameras

1 75–300mm F4.5–5.6 zoom lens

1 28–85 F3.5 zoom lens

1 24mm F2.8 wide-angle lens

1 200mm F4 macro lens

2 1.4x teleconverters

2 electronic cable releases

2 mechanical releases

In our two, wheeled carry-on cases:

Case one

1 600mm F4 lens

1 300mm F2.8 lens

2 PN11 extension tubes

2 SB26 flash units

1 Litedisc reflector

1 Litedisc translucent diffuser

Case two

1 500mm F4 lens

1 300mm F2.8 lens

1 Nikon F4 camera

1 Nikon 8008S camera

2 Minolta IVF lightmeters

1 set of small jewelers' screwdrivers

Camera/lens-cleaning kit

Notebook

Pens

In Mary Ann's smaller carry-on bag:

All our film (approximately 250 rolls between us for an 18-day trip)

In our checked-in luggage:

2 Gitzo tripods (a 320 and a 241, with ball heads detached and packed separately)

2 Groofwinpods

8 empty beanbags

1 Quantum Battery One (a rechargeable battery source for my flash unit)

Assorted filters

Off-camera-flash cables

Extra AA batteries (bare minimum: three packs of 16)

If you do plan to spend more time photographing, then by all means bring along a true macro lens. They are available in several focal lengths, which typically range from 50mm to 200mm. My favorite is the 200mm macro lens because it provides a greater working distance. At 1/2 life size, I can be twice as far from a subject with the 200mm than I can with a 100mm, and four times further away than I could with a 50mm lens. That's important when I'm trying to obtain a frame-filling head shot of a wary agama lizard outside my tent.

Tripods and Other Camera Supports

Tripods aren't necessary for most safari game drives. You will do most, if not all, of your shooting from your vehicle's open roof or windows, where you can use a lens rest or beanbag to support the camera or lens. If you're the only photographer in your vehicle and have plenty of room, you could use a tripod, but it isn't very practical when beanbags work so well.

Still, I pack a tripod for midday shoots around the lodges when I'm filming macro subjects or nearby birds and mammals. I take a small tripod such as the Gitzo 320 or 241 Pro Reporter for safaris. Used at minimum extensions, they're sturdy enough to handle long lenses. I use tripods for capturing sunrises and sunsets; I also use them for scenics, and even for recording some game from outside the vehicle. Some parks have foot trails that lead to hippopotamus wallows, and I almost always shoot hippos off a tripod in these areas.

If you have a vehicle to yourself, or have permanent access to a window, you might consider getting the Stable Windowframe Mount (see page 142 for resource information). This extremely stable window brace locks firmly to the vehicle window.

In our vehicles, I normally use a Groofwinpod, which is a foldable, tablelike support that braces to a window frame. It is equipped with a 3/8-inch bolt for securing a standard heavy-duty ball head, although I use mine without this tripod head. Instead, I use the Groofwinpod as a support on which to lay one or several beanbags.

Beanbags are a common camera support. Filled with beans or rice, your bag should be at least double the size and mass of the bags used in a beanbag

PHOTOGRAPHERS AT SUNRISE

It is worth the trouble of bringing your tripod just for the chance to photograph sunrises and sunsets, and you'll definitely need a firm support from this lower camera perspective.

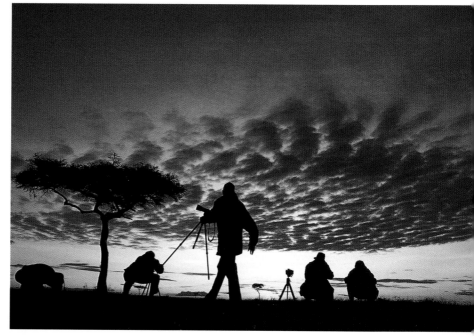

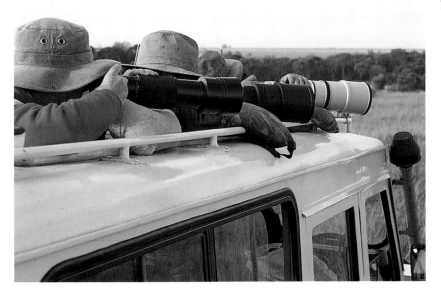

Beanbags make sturdy supports for shooting from the top of your vehicle.

game. I suggest having two 4 x 10 x 2-inch bags, and perhaps another that's about half that size. You'll find the smaller bag useful for propping up the front of your lens or the back of your camera to achieve small compositional changes. I fill these about 4/5 full so that they have a bit of give. In this way, I can nestle my lens snugly into the bags. When a bag is stuffed solid, you have to balance the lens on it, and this isn't as stable as wedging the lens into a partially filled bag.

Use bags that seal with zippers, not velcro. Zippers are less likely to pop open at inopportune moments, unlike velcro closures, which often open, spilling beans or rice into your van, equipment, or gadget bag. Any good seamstress can sew a couple of bags (my mother made mine), or you can buy them.

It goes without saying that you shouldn't pack a filled beanbag in your luggage! Full bags weigh a few pounds, so you should fill them when you arrive in Africa. Do this before you leave for the bush; beans will be less expensive in the major cities, but if you don't have time, you should be able to pick up beans or rice at local markets *en route*.

Flash

Most photographers rarely use a flash while on game drives, but you may still find one handy for taking snapshots around camp, or for photographing people and macro subjects. A through-the-lens (TTL) flash system, one in which the camera automatically calculates the flash exposure for you, is ideal.

If you're comfortable using a flash, consider packing along a teleflash. A teleflash system incorporates a fresnel lens to concentrate or focus the flash's beam into a constricted area, providing an increase in the flash's working distance that is a number of times greater than the norm for a given f-stop. For example, consider a teleflash system that uses a fresnel lens that increases a flash's power by a factor of three: if the flash's guide number (GN), or power rating, is 120 for ISO 100 film, it would be 360 with the teleflash. Used as "fill flash," a teleflash can fill in distracting shadows when you photograph animals in partial shade or at high noon under harsh and contrasting light. Most teleflash systems are a bit large and cumbersome to use, but the results are worth the trouble.

Using a Teleflash System

Let's consider this example. Suppose you were photographing a Verreaux's eagle owl in the late afternoon in a tree 43 feet away with a 500mm F4 lens and a hotshoe-mounted flash with a guide number of 120 for the film you're using. With this system, the correct exposure would be around $f/3$ (between $f/2.8$ and $f/4$). That's not enough light for the F4 lens, so the image would be underexposed. By adding a 3x fresnel teleflash, the guide number would now be 360 (3 x 120) and the exposure around $f/9$ (between $f/8$ and $f/11$). So, you'd have plenty of light for the F4 lens.

In fact, you can even extend your flash photography with a teleflash. With an aperture of $f/4$, you could photograph a subject that is 90 feet away! These calculations are based on this simple formula:

Guide number/f-stop = distance

In our example, this would be 360/4 = 90 feet. In the field, it is often difficult or tedious to determine exact distances, but this shouldn't be a major concern because the TTL flash will yield the correct exposure, provided you're within the new, increased working distance for the flash (in this case, 90 feet). However, as a matter of course when I'm using flash during the day, I usually dial in a -1 or -2 flash compensation so that the flash only provides "fill" light and doesn't overwhelm the ambient light. This compensation is easiest to do with flashes such as Nikon's SB24, 25, or 26, or EOS's 540EZ, which have this exposure compensation feature. The result is a picture that looks natural, with shadows that are "filled in" by the flash.

Several manufacturers make teleflash systems that vary in their complexity and the amount of light they provide. The Project-A-Flash system by Tory Lepp is the simplest to use, as the molded plastic support easily fits into a large vest pocket. It increases a flash's output by a factor of two or three. The Nature's Reflections and the Poleschook teleflash systems increase the light output even further—by a factor of 3 or 4 with the former, and 5.7 with the latter. This increase does come at a cost, both in the expense of the units and in their bulkiness. However, if you need to use a flash in the field, any of these three will certainly help.

Manual and Electronic Releases

Although I'd suggest having one along, I find that manual and electronic releases have limited use. In fact, many novice safari photographers, using older cameras that lack automatic film advancing mecha-nisms, miss shots as they waste time going back and forth between the camera's film advance lever and the release.

With electronic cameras (which advance the film automatically after each shot), it is a toss-up whether or not to use a release. Most times it probably isn't necessary. Besides, it is just another thing to worry about tangling up or breaking while you're rushing to get a shot. A release is most useful when you're trying to avoid image degradation due to camera shake. This typically occurs at slow shutter speeds, which for the most part you won't be using for wildlife photography. Of course, when it is necessary I do use releases, especially when I'm using a tripod and long telephoto lenses with teleconverters to capture sunrises or sunsets. Sometimes, in low light and with a long lens, I'll use a release if I feel that any movement on my part (including even my index finger depressing the shutter) could cause the camera to shift.

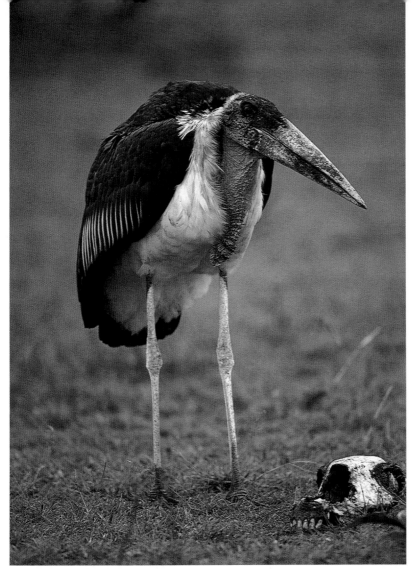

MARABOU STORK
WITH ZEBRA SKULL
*500mm F4 lens, 1/125 sec.
at f/4, Kodachrome 200 at
ISO 250.*

*I rarely use a cable release
when on safari, but
sometimes the light is just
too low not to. For this
shot, I asked the other
people in my vehicle to be
dead-still as I squeezed off
several frames with an
electronic cable release.*

Filters

I rarely use filters in wildlife shooting. But if I'm shooting scenics or animals in their natural habitats, I'll frequently add a polarizing filter to intensify blue skies, accentuate clouds, or reduce glare in vegetation.

I use a variety of filters on different occasions; my favorites include Tiffen's graduated neutral-density filters of 1-stop and 2-stop gradations (from top to bottom of the filter), and Tiffen's warm-polarizing filter and 81A, 81B, and 85B warming filters for sunrises and sunsets. Neutral-density filters are good for photographing in bright sunlight because they reduce the amount of light reaching the film; they are neutral in color, so they don't affect color transmission. Polarizing filters cut down on reflective glare, which often results in more saturated colors. Warming filters create a warmer cast to an image. If you're comfortable using filters on your domestic trips, then by all means, pack all the filters you normally use. They take up very little room.

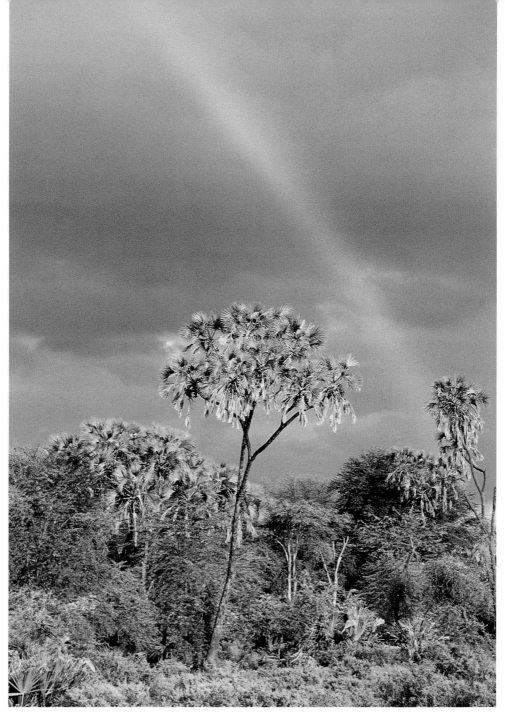

RAINBOW AND DOUM PALM IN SAMBURU
35–70mm F2.8 lens with polarizer, 1/30 sec. at f/8,
Fujichrome 100.

I used a polarizer, or polarizing filter, to enhance this rainbow, rotating the filter until it was in a position where the rainbow was most vivid.

Reflectors

I use reflectors and light-scattering diffusers to photograph macro subjects such as flowers and insects, and to create fill light in outdoor portraiture. Keeping that in mind, it is obvious that a reflector has limited usage on an African safari. The kinds that I use most often are the gold reflector and the translucent diffuser; I use the gold reflector to warm up faces for portraits and the diffuser to soften light on macro subjects. My reflectors flip open into a large round disk, and collapse to about a third of their original diameter when twisted in a figure-eight motion.

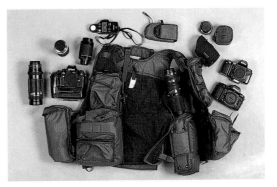

Photo vest with gear.

Backgrounds

If you're a serious macro photographer, you should consider packing a painted cardboard background to place behind your macro subjects. I carry a 10 x 12-inch board that fits inside my airplane carry-on case. Although it is small, it provides a sufficient background for spiders, insects, and small chameleons.

Gadget Bags, Lens Cases, and Photo Vests

Although it may not be very practical, I use two different packing systems when I travel. When I fly, and when I travel between camps, I pack my equipment in the type of carry-on cases commonly used by airline crews. These cases are within the correct dimensions for almost all airlines, and have wheels, collapsible handles, and a couple of zippered flaps for books or documents.

In the field, I use lens cases and a photo vest. I keep my largest lenses inside Domke bags designed for the next larger lens sizes (if available) than the ones I'm using. For example, I use a 500mm lens bag for my 300mm lens and a 600mm bag for my 500mm lens. (I'm stuck with a 600mm bag—the largest—for my 600mm, however.) As I stated earlier, with these larger bags, I can keep a camera mounted on the lens and ready for use.

I pack spare cameras, small lenses, and my flash gear in my photo vest, which I also hang over the back of a seat. I'm a big fan of vests, especially when I'm flying. As you probably know, many airlines limit carry-on luggage to one bag, but by wearing my vest,

Although I use my photo vest in the field, I also find it especially useful as an extra piece of carry-on luggage when I fly. I put all of my breakable accessories, filters, small lenses, flash units, and several camera bodies inside it.

I can keep the rest of my breakable equipment, which wouldn't fit inside the carry-on case, with me. I use a Vested Interest Magnum Vest, which accommodates all but my longest lenses.

Although any number of methods are available for carrying gear, it is important to have your equipment readily available for shooting. I suggest devising a carrying system before you go, using your car as a substitute safari van; practice removing the gear from the bag or case that you intend to bring.

Film

Film choice is a very personal decision, based in part on the colors you prefer, the amount of graininess of the film or print that you'll tolerate, and the ISO speed you'll need for the lenses you use. Most photo safari participants prefer slide over print film, for several reasons. Professional photographers, and those who aspire to sell their work, use slide film because most commercial markets require it. Many camera-club members also opt for slide film because they project their work at club meetings or submit it to competitions. Other people simply like the color, even if they'll later convert their best slides into prints.

Slide film is less expensive than print film, when you consider processing into the total cost. If you normally shoot prints, but are considering making an album or exhibiting enlargements of only your best work, it might be less expensive to convert slides into prints, rather than going through the expense of making small prints first, and then enlarging from these. Anyway, that's my argument, but I'd hate to see someone shooting with a brand new film type for the first time on safari based solely on my recommendation. Practice and do some tests at home before you go.

A film's sensitivity to light is called its ISO (International Standards Organization) rating, or film speed. The slower the ISO of a film, the finer its grain and the sharper the images will be—provided other factors, such as focusing or subject movement, don't degrade the image. Slow (or low-numbered) films, such as ISOs 25, 50, and 64, require signifi-

cantly more light to properly expose an image than fast (or high-numbered) films, such as ISOs 200 and 400. Fast ISO films are typically grainier, and not as true or vivid in color, than their slower ISO cousins. I recommend taking a mixture of slow and fast films with you on safari; this will enable you to use the sharpest, most colorful slow films on sunny days, and grainier, high-speed films when the light is poor. Again, you should base your decisions on exactly which films to use on your own tests, because each film renders a scene in its own unique way.

I suggest trying Fuji Velvia at ISO 50 or Kodachrome 64 for your fine-grain, good-light film. Fuji Velvia's color really pops, and although I once used Kodachrome almost exclusively, I've gradually converted to Velvia for its brilliant, attractive color and superb sharpness.

My general-purpose, mid-speed film is Fuji Sensia at ISO 100. The film is sharp, and Sensia's colors are perhaps even more accurate than Velvia's, which look "toned down" in comparison. Kodak's Lumiere is an attractive alternative, especially for brown subjects, because this film offers the greatest palette of earthy colors, and the film is also very sharp. Lumiere X and Kodak's Elite films are, to my tastes, biased too much toward yellow and gold, and are too unnatural for me. I also find Lumiere's 100 ISO inaccurate—it results in dull, slightly underexposed images. For better exposures with this film, I set my ISO dial at 80 to compensate and, if necessary, also bias my exposure by slightly overexposing.

When the light is low, I switch to Kodachrome 200, which I rate at ISO 250 for a slight increase in color saturation. Kodachrome is sharp but grainy, and will give you reasonably fast shutter speeds in all but the dimmest light. It is my favorite film for use under a heavy, overcast sky or when the light is low, which is usually either early or late in the day. I find Kodachrome 200 rather contrasty in sunlight, so I usually change to a slower ISO film for bright conditions.

It is important to note that if you change the ISO of a film for a personal preference in color saturation or light sensitivity, as I do for Kodachrome 200, you should not "push" the film for developing. Pushed

Different Films for Different Light

I think it is helpful to compare the four films I normally use on safari (at the shutter speed/aperture combination I'd normally expect to use) under four different lighting conditions. This is not meant to be a guide on which to base your exposures, but instead to illustrate the applicability of a film for photographing wildlife under various light levels.

Film and ISO	Bright sunlight	Cloudy (bright light)	Cloudy (heavy overcast)	Heavy overcast at dawn or dusk
Fuji Velvia 50	1/500 at f/4–5.6	1/250 at f/4	1/60 at f/4–5.6*	Not realistically possible
Kodachrome 64	1/500 at f/5.6	1/250 at f/4–5.6	1/60 at f/5.6*	Not realistically possible
Fuji Sensia 100	1/500 at f/8	1/500 at f/4–5.6	1/125 at f/5.6	1/125 at f/2.8
Kodachrome 200	1/500 at f/11*	1/500 at f/8–11	1/250 at f/5.6	1/250 at f/2.8
Fuji Sensia 400				1/250 at f/4

(Not recommended)

film is processed differently than regular, nonpushed film. Don't have the film push processed! Send it in to your developer as you would any other film. Changing the ISO a small amount is no different than purposefully over- or underexposing your film, or using the exposure compensation dial, to achieve a look or saturation you prefer.

You should base the amount of film you bring with you on your usual shooting habits. Most of my safari participants shoot between 50 and 120 rolls of film on an 18-day safari. The reasons for this large range vary, of course; some photographers don't shoot as many subjects, others shoot everything and often in multiples, and still others bracket their exposures. I suggest carrying at least 20 rolls of film with you on every game drive. Most amateur photographers shoot about half that per drive, but you could easily shoot three times that amount if you came upon a series of outstanding subjects.

Mastering Technique

THE SHARP SOUND of crunching bones stopped, and the spotted hyena stepped back from the now unrecognizable carcass. Where lions had gorged on a huge buffalo only a few hours earlier, little more than a rib cage, skull, and some red-stained grass now remained. The 50 vultures that encircled the hyena and carcass now moved closer—a sea of birds shifting expectantly, hissing like dragons as they hopped forward through the short grass.

SPOTTED HYENA
500mm F4 lens, 1/500 sec. at f/8, Fujichrome 100.

Shooting from my vehicle window, I braced my lens on a couple of beanbags for maximum stability and focused on the hyena's eyes. The vertical composition complements the image most effectively.

No matter how many times I witness this primal drama—one that draws spectators from around the world—my excitement never wanes and the challenge to photograph it never decreases.

To make successful pictures, I must know what my camera equipment can and, perhaps more importantly, cannot do. A safari is *not* the time or place to experiment. Still, I often see eager photographers overburdening themselves with brand new gear and confusing themselves with new, unfamiliar techniques. Don't do it! If you're happy with your images at home, don't change what you do when you're on a trip. If you're considering trying new methods, do so long before you head out on safari to give yourself plenty of time for testing.

Troubleshooting Potential Problems

Photography is supposed to be fun, but the stress of making great pictures sometimes spoils this enjoyment. Quite often, this stress is due to equipment problems—some of them real, some imagined. Either way, photographers often panic at the first mechanical glitch or incorrect exposure reading.

It is true that equipment can malfunction, and sometimes does so without warning or cause. For example, on one of our last trips, the shutter in one of Mary Ann's cameras broke without any indication that it had done so. She lost a lot of great shots, but we also learned a valuable lesson from this tragedy: Don't ever take your gear for granted.

Oftentimes, however, many problems occur due to a lack of familiarity with equipment or basic photographic principles. You can prevent these types of glitches if you give a little time and thought to your normal operations. For example, you might incorrectly expose your film by setting an ISO or exposure-compensation dial improperly or by misreading the DX code on a film canister. Or, you might not be able to focus your autofocus lens simply because you switched your camera to manual focus by mistake.

Imagined problems can be even more vexing because they undermine your faith in your skills or camera. More than any other time, this happens when photographers compare their exposure settings. Believe me, nothing is more frustrating than finding that the meter readings of your camera don't agree with the cameras of the photographers around you.

Checking Exposures

Place yourself in this scenario: You and another photographer are filming a giraffe. The animal is in sunlight but is framed against a dark, forested background. The giraffe is close, with its huge eyes boring into your autofocus 75–300mm zoom lens, which you have set at around 75mm. Now, the giraffe steps back, taking a couple of long, unhurried strides. Zooming your lens out to 300mm, you're about to snap a picture when your friend says, "I'm at 1/250 sec. at *f*/8. What are you?" You're at 1/125 sec. at *f*/5.6. You're both using ISO 100 film, so why are you off by two stops?

Your immediate reaction might be that something is wrong with your camera. But, different lenses and metering methods might account for your two-stop discrepancy. If this is the case, technically, both exposures could be correct. Suppose that your friend is using a fixed 300mm lens, not a zoom like you. With some zoom lenses, the *f*-stop changes when you zoom the lens from its shortest to its longest focal length. (These lenses are said to have "floating apertures," and are always identified by two minimum apertures inscribed on the lens barrel.) This could be part of the problem because, at 300mm, your lens loses one stop. With your friend's fixed-focal length lens, the aperture setting would be the same or close to the exposure you'd have if you zoomed your lens to its minimum focal length of 75mm, since there's no light loss at that focal length. If that's the case, then the two-stop difference in exposures is really only one.

The use of different metering methods could also cause this reading discrepency. Perhaps you're using matrix metering, while your friend is using spot metering. Matrix metering reads the entire picture area, including both the giraffe and the background, so a dark background could bias your exposure. If your friend obtained his reading via a spot metering of a middle-tone area, a two-stop difference is possible.

Chances are, the spot-metered giraffe would be the correctly exposed image because this exposure isn't influenced by the background.

If you're concerned about the accuracy of your camera's exposure meter, shoot a roll of slide film of a variety of outdoor subjects before your safari. Be sure to cover a wide range of light and color tonalities. Always use slide film for this, because the true exposure isn't altered in the developing process, as it can be with print films.

If you have real concerns about your exposure meter while on safari, compare your meter with those of several others in your group. Take readings off a gray card or a blank wall in unchanging light with similar lenses that are all focused at infinity.

Fixed-focal length lenses work best for this test because, as I mentioned earlier, their apertures don't change. Most cameras are accurate, so chances are there will be a group consensus on the correct exposure. If you're off and you know the error is meter-based, not due to your lens, change your ISO setting until you obtain the correct reading. You can also use the exposure-compensation dial to do this. Once set, keep the ISO or compensation dial at the new setting for the film you're using, and don't worry about your exposures unless you're significantly off from others in your party. Keep in mind that any discrepancies might be because of a filter, or a difference in the areas you're metering, or an exposure compensation that you changed.

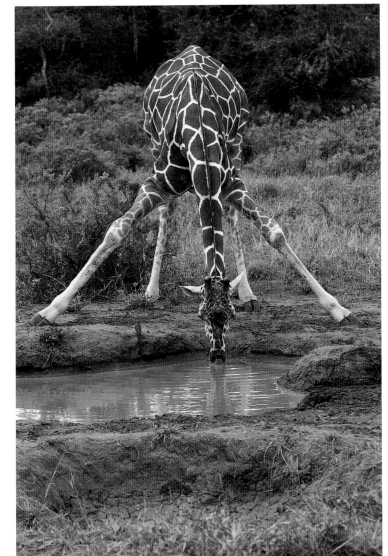

RETICULATED GIRAFFE DRINKING
75–300mm F4.5–5.6 zoom lens, 1/250 sec. at ƒ/5.6, Fujichrome 100.

It is important to know your lens' capabilities. For example, does your exposure change when the focal length of the zoom lens changes? For this shot, I used a floating-aperture lens and adjusted my exposure after zooming from 75mm to 300mm. If I had zoomed before determining the exposure, I would have underexposed the giraffe.

Checking the Aperture

It is also very helpful to periodically check the mechanical operation of your camera and lenses. Since you determine exposures by the shutter speed and lens opening (or aperture), it is important that both your shutter and aperture work properly. Be sure the aperture closes down (closes all the way). To check this, set the lens at its smallest f-stop; depending on your lens, this will vary from $f/16$ to $f/32$. You must set your camera on either the manual or aperture-priority exposure mode for this test, otherwise the aperture might stay wide open if the ambient light is dim. If your camera has a depth-of-field preview button, depress it—the viewfinder should darken considerably as less light enters the lens. If this happens, the aperture is working fine. If there's no change, check your aperture and camera settings. Remember, the aperture might not close down if your camera is set either on a programmed mode or on shutter-priority exposure mode.

If your camera lacks a preview button, you can still check your aperture operation. Again, set your aperture at its smallest opening and your camera on manual mode or aperture priority. Since the aperture closes when the camera fires, make sure you're using a slow shutter speed so you can actually see this happening. Look into the front of the lens and click the shutter. If you can't see the aperture close

Checklist for Comparing Exposures

If your exposures differ from those of the other photographers on your safari, ask yourself the following questions. All of these factors affect exposure readings in some way and could account for any discrepancies.

Are you using the same ISO film?
Your exposure won't agree with others if they're using different ISO films.

Is your camera set for reading a film's DX code, or must you set the ISO manually?
Check this in either case, because your camera can make an incorrect reading, or you might have made an error when setting the ISO.

Is your exposure-compensation setting on 0?
Keep in mind that you might have forgotten to reset your exposure-compensation dial after shooting a non-middle-tone subject, or you might have turned the dial by mistake.

Does your lens have a floating aperture?
If so, you should keep this in mind because the exposure changes when you zoom to the lens' greatest focal length. To make an accurate exposure comparison, zoom the lens to its minimal focal length and then compare the readings.

Is your lens focused at infinity?
At shorter distances, some lenses lose light. With a macro lens at minimum focus, for example, that loss might be one or even two stops of light! By keeping the lens at infinity, you'll ensure that the maximum amount of light passes throught the lens.

Are you using a 1.4x or 2x teleconverter?
Remember that you'll lose one or two stops of light, respectively, with these teleconverters, and this will affect your exposure settings.

Are you using a filter?
Polarizing filters reduce exposures by one or two f-stops. Color filters reduce light, too, usually by a stop or more.

down, you may need to angle the lens into the light, since the aperture may be deep within the lens barrel. When you try again, you should see this happen.

If the lens doesn't close down, there might be a faulty electrical connection caused by dirt or grit at the contact points between the camera and lens. Clean these contacts, or use a blower-brush to remove any obstructions. If that doesn't work, check your camera to be sure that it isn't the problem. Mount a different lens, and try again. If the new lens closes down, the problem is with the original lens, not the camera; if the new lens doesn't close down, it is a camera problem. If there isn't any dirt and if a simple cleaning doesn't clear things up, use your spare camera.

Checking the Shutter

To check your shutter operation, put your camera on manual mode and set your shutter speed to 1/2 sec. or slower. Remove your lens, and fire a frame while looking into the camera body. When the mirror flips up and the shutter opens, you'll see the shiny surface of the film, or the film plate if your camera is empty. If everything is okay, you'll have a clear window (an unobstructed view). If the shutter is jammed, you'll note that the shutter curtains aren't opening completely. If so, switch to one of your backup cameras, because you really can't get a shutter fixed with any certainty while afield.

If you check your aperture and shutter operation every few days while on your trip, you'll minimize the chance of a camera malfunction ruining your images.

Checking the Autofocus

If your autofocus isn't working, check both your camera and lens settings. Many lenses have a switch restricting the focus to a specific range, which varies from full coverage to a minimum close-focusing distance. If your lens won't focus near or far, check this switch. Check, too, that both your lens and camera are set for autofocus. If all the settings are correct and your lens still won't autofocus, inspect the lens and camera contact points for dirt. A gentle cleaning of the contacts should correct the problem.

MARABOU STORK AT SUNSET
75–300mm F4.5–5.6 zoom lens, 1/250 sec. at f/8, Fujichrome 100.

Determining Exposure

Assuming your camera meter is accurate, which it probably is, there is still the problem of obtaining proper exposures. Many photographers simply trust their camera's automatic functions to produce satisfactory results. While that works 90 percent of the time, camera meters do have limitations, and if you know these, you're more likely to make good exposures every time you shoot.

DRONGO
300mm F2.8 lens with 1.4x teleconverter, 1/250 sec. at f/5.6, Kodachrome 64.

From a distance, drongos aren't very impressive, but a close-up image reveals their red eyes and rich, black plumage. I metered a middle-tone area and overexposed by 2/3 stop. This enabled me to capture detail in the feathers without creating an unnatural overexposure.

All exposures are based on the concept that the "correct" exposure is basically middle toned, or gray if we think in terms of black or white. A photographic gray card represents this middle tone.

Every color has a middle-tone range, too. It might take some practice to recognize the mid-range of all tonalities, but even a novice can recognize a deep maroon from a pale pinkish hue, and somewhere between those extremes exists a middle-tone red. Your camera meter provides an aperture and shutter-speed setting based on a tonal reading, not on the actual color of your subject. In other words, your camera doesn't know what subject or color you're aiming it at. Fortunately, most safari subjects are, or are close to, middle-tone values. Much of the African landscape is composed of earthy browns or medium-tone greens, so you can even correctly expose subjects that are not middle tones through matrix, or multisegmented, metering.

Despite the fact that many safari subjects are medium tones, it is certainly always helpful to recognize scenes or animals that are not. An incorrect reading might result in an incorrectly exposed photograph. Since exposure is so critical, in chapter 5 I'll cover the tonalities of many of the birds and mammals you're likely to film on safari. By following those suggestions, you should be within a suitable exposure range for these subjects, and your images should be fairly accurate.

Subjects that aren't middle toned can be troublesome to photograph because your camera still reads white and black as gray. By simply trusting your meter, a black African buffalo will be overexposed and a white African pelican will be underexposed; this is because the camera meter compensates by increasing the exposure for a dark subject and decreasing it for a light one. For either animal to look natural, you must recognize their actual tonalities, and amount of light reflectance, and adjust your exposure accordingly.

There are a couple of ways to do this. One method is to risk letting your camera make the decisions, based on a reading of the entire picture area; in some situations, there will be enough middle tones in the scene (for example, a hippopotamus in

a green marsh) for a satisfactory exposure. This is the beauty of matrix metering, in which the camera considers several areas of the composition before reaching a remarkably accurate compromise.

If your non-middle-tone subject fills the frame, you'll probably have to make some type of adjustment to obtain a correct exposure. If you use one of the automatic modes, either programmed, aperture-priority, or shutter-priority, you could use the exposure-compensation function to bias the exposure. For black or very dark subjects, set the exposure compensation to -.7, -1, or even -1.5 to purposely underexpose your subject; by doing this, darks will still appear darker than middle tone, as they should be. For white or light subjects, set the compensation to +.7, +1, or +1.5 to purposely overexpose your subject. After using the exposure-compensation dial for a particular shot, *make sure you reset the dial back to zero* to avoid making incorrect exposures on subsequent shots.

I always worry about forgetting to do this, which is one of the reasons I rarely use the exposure-compensation dial. Instead, I determine almost all of my exposures manually, using my camera's spot-metering mode. I simply take a reading off my subject, and go with it, or I correct the exposure by changing the aperture or shutter speed after I make the reading.

For white subjects, you'll have to do some thinking. If you meter off something white, the meter reads it as gray, and the finished slide will look dark and underexposed. To compensate, just overexpose off the reading, usually by 1 or 1½ ƒ-stops. For black or very dark subjects, which will be overexposed if metered directly, underexpose after taking the reading. When I photograph black subjects, I am more comfortable metering a middle-tone object that is in the same light as my dark subject, and then overexposing to compensate. Remember, black reflects less light than a middle tone does. This is a fail-safe method for me because even if I forget to overexpose after metering the middle tone, I can still expect a decent exposure, since the dark subject will look dark. Usually, for a frame-filling black subject, I overexpose off my middle tone by 2/3 or 1 ƒ-stop.

Charles Campbell, author of *The Backpacker's*

Photography Handbook (Amphoto, 1994), has devised a clever method for determining subject tonality. It is called the Chroma-Zone Exposure System, and it uses a series of 21 small cards that are colored the various shades found in nature. After matching a color card with a subject, you meter the subject and adjust your exposure either up or down according to the recommendation on that particular card. The cards are small and easy to pack, and even if you don't use them on safari, you'll find that they are worth having for practicing with exposure tonalities before your trip.

Note that the metering information I've provided here is very general because my main goal in this book is to assist your overall safari photography, not to teach basic photographic principles. However, there are many technical photography books available if you're unclear about basic metering.

Shutter Speeds for Safaris

Fast shutter speeds are the rule on safari. In most cases, your first priority will be to stop motion. Although many animals are fairly still much of the time, when action does occur you'll need a fast shutter speed to catch it.

A faster shutter speed is also useful because your vehicle isn't the most stable shooting platform you'll ever enjoy. Even if you settle your lens snugly into your beanbag, you may notice movement or wobbling in your viewfinder. This is especially true with a long lens if other photographers move, rocking the vehicle when they do.

I suggest using a minimum shutter speed of 1/125 sec. for most photography made from inside a vehicle. Lenses that are longer than 300mm may require even faster speeds because the magnification of long telephoto lenses also magnifies all movement. Animals in action require even faster shutter speeds, usually 1/250 sec. or greater. If you want to freeze a leaping eland or a launching bird, use 1/500 sec. or faster. It is also helpful to pan with the action, following the direction of your subject's travel with your lens. This is especially true if your subject fills the frame, since motion is exaggerated up close. Of course, you can

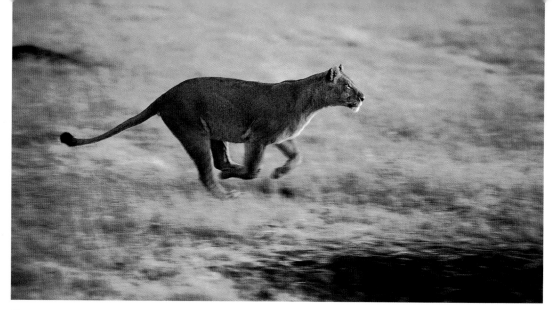

RUNNING LIONESS
300mm F2.8 lens, 1/125 sec. at f/5.6, Kodachrome 64.

You can use shutter speeds and blurriness to effectively convey motion. This lioness moved quickly enough for the background to remain blurry even at a moderately fast shutter speed.

use slow shutter speeds if both your subject and your vehicle are still, or if you're trying a special effect. I often use a speed of 1/30 sec. when everyone inside the vehicle is still and my subject is motionless.

Depth of Field

Depth of field is the area of acceptably sharp focus that extends in front of and behind your subject or point of focus. Biasing your exposures for fast shutter speeds comes at a cost, and it is in the depth of field that your image enjoys. In any proper exposure, you have a variety of correct shutter speed/aperture combinations available to you: light either reaches the film quickly, through a large aperture opening and a fast shutter, or it travels through a smaller opening over a longer period of time (a slower shutter speed). So, as the shutter speed increases, or becomes faster, the aperture size also increases to let in more light in this shorter time frame. However, as your aperture size increases, your depth of field decreases or narrows. If you want a large area from near to far to be sharp—in other words, you desire great depth of field—you'll need a small aperture opening.

In photographic terms, we commonly refer to "opening up" or "closing down" an aperture to denote changes in the aperture size. When opening up, you're making the aperture larger; paradoxically, larger apertures are represented by progressively smaller numbers, such as $f/5.6$, $f/4$, and $f/2.8$. When closing down, you're making the aperture smaller; smaller openings are represented by larger numbers, such as $f/16$, $f/22$, and $f/32$. Confusing, huh?

Actually, it shouldn't be. These numbers refer to the size of the aperture opening, or the hole the light passes through. At $f/4$, for example, four circles the size of that opening would fit between the lens' focal point and the film plane. At $f/32$, 32 circles of that size opening would fit in that space. If you consider f-stops in this way, the numbers will suddenly make sense.

Obviously, you must reach some type of compromise between shutter speed and depth of field. Ideally, you'd like to have everything sharply in focus.

Most times, an aperture of *f*/5.6 or *f*/8 provides sufficient depth of field to attain a reasonably sharp subject while also allowing for some discernible details in your foreground and background.

For example, imagine you're using a 300mm F4 lens to make headshots of a lion that is only a few meters from your vehicle. Up close, at *f*/4, it is likely that only the eyes of the lion will be sharp. The lion's nose and ears, which are beyond the depth of field at *f*/4, will be blurry, and so the resulting image will be distracting. At *f*/8, however, the depth of field increases, not enough for the nose and ears to be razor sharp, but enough that they'll have discernible shape so that the lion's face will look complete. At *f*/22, a slow extreme, you'd have maximum sharpness, but the overall image might look fuzzy if the shutter speed is too slow for the possibly unstable shooting conditions.

Of course, one way to enjoy both fast shutter speeds and small aperture openings is to use fast ISO films. But, as I mentioned in the previous chapter, fast-speed films are grainy and often lack the trueness of color that slow-speed films have. However, if you stay within a range of ISO 50 to ISO 200 or 400, using progressively slower ISO films as the light intensifies, you'll have a reasonable choice of usable settings and good color, too.

Autofocus Lenses

Only a few years ago, the autofocus function was a crude crutch for the visually handicapped. It was somewhat slow to focus and only marginally accurate, especially with moving subjects, but that's definitely not the case today. Today's autofocus systems are fast and quite accurate. They're a great help to every-

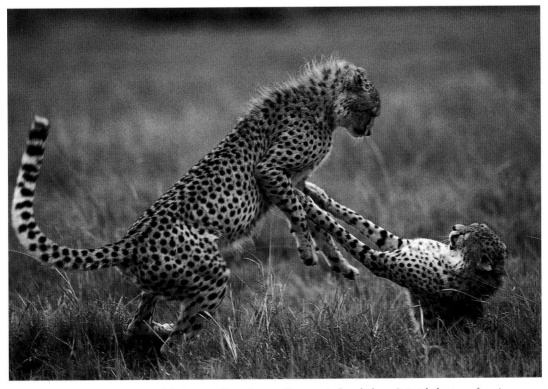

CHEETAH CUBS PLAYING
300mm F2.8 lens, 1/250 sec. at f/2.8, Kodachrome 200 at ISO 250.

My fast autofocus lens really came in handy here. I simply kept my focusing brackets on the cats and fired as they played tag and wrestled around my van.

one—whether you have good or poor vision—and they can be invaluable when you're shooting action.

Despite its value, there are two potential downsides to autofocus. One is that when used continuously, autofocus eats batteries ravenously. So, unless your vision is poor and you need autofocus to ensure sharp images, I'd suggest you use this function only when necessary. This will not only save batteries, but might also help you avoid the other potential negative to using autofocus—poor composition.

The focus sensor in most autofocus systems is located in the center, or across the midline, of the frame. So, autofocusing requires centering, and too many folks just keep the subject in the center of the composition when they focus, instead of recomposing after focusing. To recompose after getting your subject in sharp focus, depress the autofocus lock that's located either on the lens or on the camera body, and reposition your subject where you want it within the frame. In this way, you'll achieve some variety in your compositions. Don't release the pressure on the focusing lock, or the lens will focus on what's now in the sensor area.

Modern autofocus systems work very well with subjects in action. And for me, centering isn't too much of an issue in these situations; I usually end up centering simply because I'm concentrating on the focus, not on the composition. So with autofocus, my subjects may still be centered, but they're more likely to be sharp. It is a feature that I recommend for action photography.

Most camera systems offer two autofocusing modes. In one, the camera fires only when it achieves sharp focus, presumably on your subject. In the other, the camera fires independently of the focus. The first mode is fine for static subjects, and you might actually save film using it, since the camera won't misfire accidentally. The second mode is recommended for action sequences, and may be necessary if your system uses a predictive-focus feature. With predictive focus, the camera not only keeps your subject in sharp focus as it moves, but also predicts the correct point of focus when the single-lens reflex camera's mirror flips up, blocking the focusing sensor. I find it practical to keep my cameras on the continuous mode whenever I'm using autofocus. Even with static subjects, there's sometimes little warning as to when action will occur, and the continuous mode is critical for those times.

Manual-Focus Lenses

Don't despair if you don't have the latest in camera technology and your system doesn't incorporate autofocus. You can do great work with a manually focused lens; it simply requires having better vision and sharper reflexes than are necessary with an autofocus system. For many, using manual focus is actually faster for everyday shooting because they don't waste time either in recomposing after achieving focus or in "tracking" (searching if the sensor goes off the subject). Manual lenses save on batteries, too. Another plus—your compositions may be more creative, since you don't have to initially center your subject.

WHITE-BACKED VULTURE IN FLIGHT
500mm F4 lens, 1/250 sec. at f/8, Kodachrome 64.

After watching the flight path of several vultures, I prefocused at a spot to which I expected a vulture to fly, and waited. This was before I owned a good autofocus system; now, I would use predictive focus to follow the bird's approach while I fired.

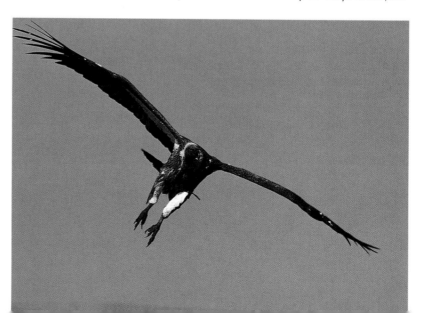

Action sequences are, unquestionably, more challenging with manual focus, but they aren't impossible. I've found manual focus useful when shooting chase scenes in which two animals occupy opposite ends of the frame. Had I used autofocus, the sensor might have focused on the area between the two animals, and I'd have missed the shot completely.

I've also shot great flying vultures in both focusing modes. On autofocus, I simply centered and followed the action, keeping my camera on the continuous mode and firing whenever the birds looked sharp. On manual, I tried two different techniques. Sometimes, I prefocused on an area in the bird's flight path, and shot the frames in the instant before the bird hit sharp focus, hoping that during the minimal time it took the mirror to flip up and the shutter to open, the bird would fly into sharp focus. Or occasionally, I would try to keep up with the bird's approach, continually manually refocusing and squeezing off frames as I went. However, for me, this method requires a calmness and presence of mind that I don't always possess.

Choosing Lens Length

On our game drives, Mary Ann and I carry similar equipment. Both of us keep our longest lenses at the ready. For Mary Ann, that's a 500mm, and for me, a 600mm. Normally, we both have a 300mm F2.8 or 300mm F4 lens mounted on a second camera body for larger or poorly lit subjects. In this way, with two different focal lengths, we're more likely to catch the unexpected.

SUNRISE WITH ACACIA TREE
600mm F4 lens with 1.4x teleconverter, 1/250 sec. at f/11, Fujichrome 100.

To make an image with a large sun, you'll need a long lens to obtain the necessary magnification. Remember that the lens will magnify anything in the foreground, such as this tree, an equal number of times, so be sure you're far enough back so that everything fits in the frame.

Regardless of your lens length, the way in which you approach birds and mammals on a game drive is very important. You'll probably frighten some subjects, especially birds, if you wait until your vehicle stops to position your beanbags or set up your lens. A better approach, if you have the time, would be to stop at a distance and get your gear in order before moving in for the shot. Our usual procedure is to place our beanbags on the roof or set up our Groofwinpods, mount our lenses, and drive in slowly until we're within range.

Concepts in Composition

How often have you sworn that you had a frame-filling shot of a bird only to find, when you got your pictures back from the lab, that the bird actually occupied only a tiny portion of the image? Our eyes tend to exaggerate our subjects' sizes and importance, and because of this, we often overlook other important elements within the frame. With so many new and wonderful subjects at hand, this "shrinking-subject phenomenon" is extremely common on safari.

LION CUB
300mm F2.8 lens, 1/250 sec. at f/8, Kodachrome 64.

As you compose, pay attention to all the elements in the picture. Had I used a longer lens (one with greater magnification) to take this photograph, I could have framed the cub against a uniform background and eliminated the tree on the right.

There's also no doubt that you'll be very excited on seeing your first elephant or leopard or dik-dik, and that you'll concentrate solely on the animal and center it in your frame. It is also easy to compositionally center wildlife for another reason. We naturally direct our attention to an animal's eyes; if the eyes aren't sharp, the image fails, so we focus on the eyes. Because of the central placement of most autofocus sensors, it is quite likely that the head, or the eyes, will end up in the center of the frame.

In this section, we're going to try to change both of these compositional problems. To start, when composing your photographs, consider all the elements within your viewfinder, and objectively assess how much of the image your subject occupies. If you train yourself to do this, your compositions will improve as you realize some subjects aren't as large as you initially thought.

As to composition, if the image size is large—if, in fact, the bird or mammal really does fill the frame—a centered image might work. But, if the animal occupies only a small portion of the frame, you should consider a composition in which all the other elements within the picture play a role. Of course, moving a subject out of the center of your frame is not an improvement if its new location doesn't complement the image. Consider all the elements that make up the scene. Are there nearby bushes or trees, or even a shoreline, that could provide a sense of habitat or lead the eye toward your subject? Is the horizon visible? Are there any visual distractions that might compete with, or pull the eye away from, your subject?

Keeping questions like these in mind, consider the concept of "power points" in your subject placement. For this, imagine dividing the 35mm viewfinder frame into sections with two horizontal lines, which are equidistant from one another, to make three horizontal blocks of equal area. Then, imagine two vertical lines that do the same, only vertically. The four points where the vertical and horizontal lines intersect are the "points of power" and are the most likely positions for your subject. I frequently consider power points when I'm composing. In this way, I'm aware of my subject's placement in the frame. At the very least, this usually keeps me from centering my subject.

Grid illustrating points of power.

COLOBUS MONKEY
500mm F4 lens, 1/500 sec. at f/5.6, Fujichrome 100.

By positioning the monkey in a "point of power," and using the strong diagonal of the acacia limb as a leading line, I made the best of a very tiny area of interest.

Perspective and Background

It is important to consider what lies in front of, and behind, your subject. Even novice photographers are usually cognizant of foreground elements and their potential to distract. However, this attention and awareness often goes no further than the subject, and as a result, many photographers completely disregard the background matter.

You can eliminate background distractions by simply shifting your camera left or right to frame your subject against a complementary background. For example, line up a perched bird with a distant hillside or a line of trees, instead of against a bright white sky.

YELLOW-NECKED SPURFOWL
600mm F4 lens, 1/250 sec. at f/4, Fujichrome 100.

It is often helpful to discuss your photography needs and ideas with your driver. On a previous shot I had explained why the bright sky was too contrasty against the birds I was trying to photograph. When we spotted this spurfowl a few minutes later, he aligned the bird against a hill, not the sky.

This might require moving your vehicle to get into exactly the right spot. Some driver/guides are aware of this, but most aren't, and it would probably be helpful for you to explain to your driver why you want to move. To drivers, one place may be as good as another, and they won't want to risk frightening the subject. By explaining your requests, you might find that your driver will begin to think for you, or will at least be agreeable when you ask to change positions.

You can also often improve your compositions by simplifying them, and that's certainly the case when dealing with background horizons and skies. These elements can be distracting, especially if the horizon isn't level or the sky is considerably brighter than your subject. Consider just eliminating the horizon line or sky altogether. Sometimes this is as easy as merely pointing the lens downward slightly to raise the subject in the frame, or moving back and using a longer lens. Note that as the size of your subject increases, the background elements get larger, too; they might even fill the picture area and eliminate the distracting contrast.

Dramatic wildlife images often imply intimacy, and you can effectively convey this by taking a low perspective, or one that is even at your subject's level. Whenever I can, I shoot close to the level of my subject; this often requires squishing down to the floor of the vehicle to shoot from a window rather than from the roof hatch. This can be uncomfortable, and consequently, most photographers shoot from the roof. Fortunately, with a long lens, and at greater working distances, shooting from the roof hatch isn't much of a problem since the longer range tends to flatten out the view, thereby implying a lower perspective.

Shooting from the roof hatch also has its advantages. Besides the comfort, you'll find it easier to securely brace a long lens and beanbag on the roof than off many window supports. It is usually the ideal spot for photographing birds, since they're likely to be at your level or even higher. Depth of field can be less of a problem, too, especially when shooting scenics. You'll find that the roof hatch provides the ideal position if, for example, a lion pride is scattered in the grass just a few meters before you.

Angle of View

With wildlife, we often think of our lenses solely in terms of their magnification power, and how large they'll make a subject appear in the frame. An equally important consideration, though, is how much area the lens includes within its view, or how much background appears from side to side in your viewfinder behind your subject. This is referred to as the angle of view, and it changes as the magnification of your lens changes. As the magnification increases, the angle of view decreases, and any changes in your angle of view can dramatically affect your compositions.

ELEPHANT AT SUNSET
*300mm F2.8 lens, 1/250 sec.
at f/2.8, Fujichrome 100.*

To raise the elephant's legs against the skyline and ensure that they would be visible, I had to sit at a low angle to my subject, and I did this by shooting from the window of my vehicle

LEOPARD IN TREE
500mm F4 lens, 1/250 sec. at f/5.6 with TTL fill flash, Lumiere 100.

Adding light to the leopard with a teleflash lessened the contrast between the leopard and sky. For greater lens stability and a better perspective, I shot from the top of my vehicle.

Drivers have a tendency to approach a subject as close as is possible. Normally, that's a plus because the shorter the working distance, the larger the image will appear on film. Of course, you can achieve the same image size at 100 feet with a 200mm lens as you can at 200 feet with a 400mm lens; this is because the 400mm lens offers twice the magnification of the 200mm. So, you maintain the same image size when changing distances from 100 to 200 feet provided you double the magnification of your lens. But, as I said before, changing your lens also changes the angle of view, or how much background you see behind your subject. With a 200mm lens, the angle of view is approximately 12 degrees; it is only 6 degrees with a 400mm lens. So remember, you'll see less background, left to right or top to bottom, behind your subject when you use a longer lens.

Imagine that a herd of zebras are scattered about on the plains several dozen yards behind your subject, which is, let's say, an impala. With any telephoto lens, the depth of field will be inadequate to sharply film both the impala and the zebras. Most likely, if you're focused on the impala, the zebras will be distracting blackish-white blurs. With a 200mm lens' 12-degree angle of view, one or several blurred zebras might be within the frame. However, by moving back and switching to a 400mm lens, with its narrower angle of view, it might be possible to frame the

impala between these blurs, eliminating them altogether. In general, you'll have an easier time simplifying your compositions with a longer lens.

Note that in this scenario we changed our working distance; we didn't just change our lens. Switching lenses, or zooming to a larger focal length with a zoom lens, without changing the working distance results in an entirely different image—you might end up with a huge impala that more than fills your frame. To obtain the same image size with different focal lengths, you must change your working distance, too. Zoom lenses are great for making compositional changes, but remember, they might also necessitate your moving to achieve the exact composition you desire.

GNU MIGRATION IN THE LOWER MASAI MARA
80–200mm F2.8 zoom lens, 1/1250 sec. at f/8, Kodachrome 64.

This featureless, gray sky annoyed me, and I looked fruitlessly for a higher vantage point from which to film this herd so that I could eliminate the sky altogether.

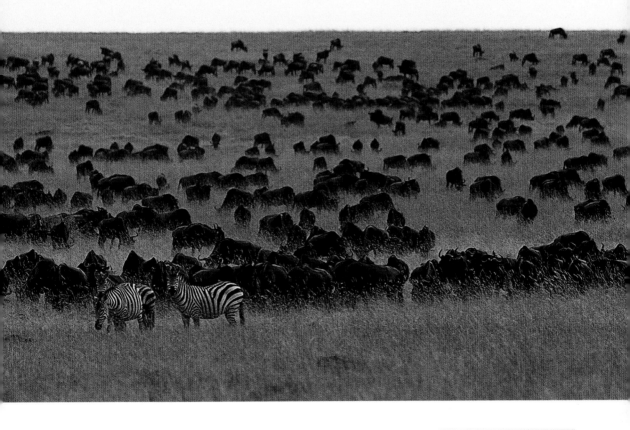

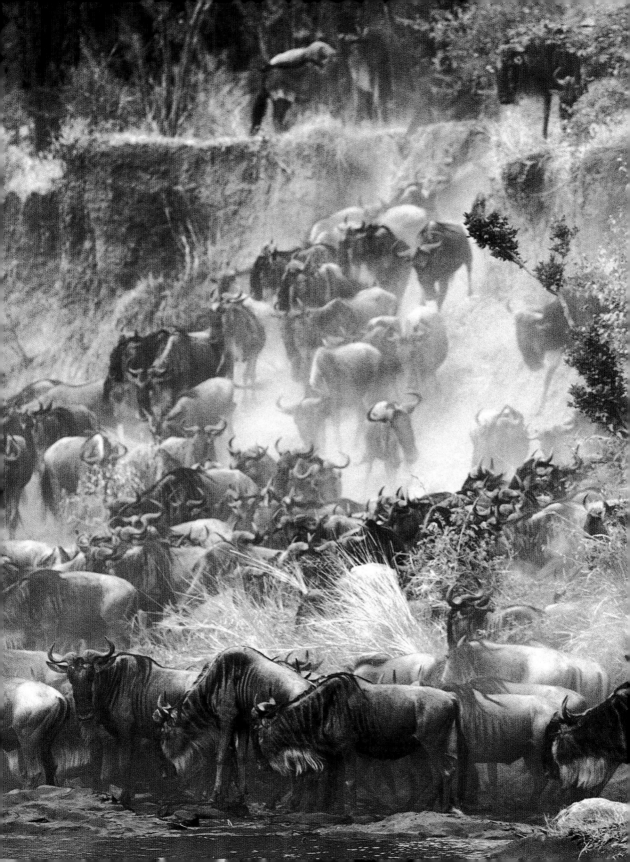

Into the Country

HAKUNA MATATA. (No problem.) This is the operative Swahili phrase in East Africa, and there should be no problems as you embark on your safari. Unfortunately, for first-timers, and even for many seasoned travelers, entering a foreign country often causes unnecessary anxiety. There are worries about hassles you might face going through customs, or concerns that your luggage won't arrive. A general sense of unease about the unknown, plus the exhaustion of a long flight, frays the nerves. But if you're prepared, your entry into East Africa should go quite smoothly. In this section, I'll try to equip you for this journey and your first few days "in country." Hakuna matata!

GNUS CROSSING THE MARA RIVER
500mm F4 lens, 1/250 sec. at f/4, Kodachrome 64.

It can be extremely difficult to get into a good position for a crossing, but it is a spectacular sight, regardless of whether you're photographing or simply watching it.

Although Kenya straddles the equator, and Tanzania lies immediately to its south, their climates are essentially the same. The word "equatorial" brings to mind thoughts of hot, steamy, humid climates, and in fact, you will encounter these conditions along the low-lying coasts of both these countries. In the high interiors, however, where most of the game parks lie, conditions are much more clement. The elevation in northern Tanzania's Serengeti National Park exceeds 4,000 feet above sea level and Kenya's Masai Mara Game Reserve tops 5,000 feet. With the blessings of favorable winds, the air is crisp and, during the dry seasons, lacks humidity. As you might expect, the tropical sun is intense, but daytime temperatures rarely exceed 85°F. At night, temperatures can drop into the 40s, although low 60s is the norm. It can be quite cold at the start of a morning game drive, a fact that surprises many safarigoers who expect tropical temperatures and dress accordingly.

The amount you pack will depend on your departure location and your mode of travel once you are in country. In the United States, airlines allow two checked-in pieces of luggage, which can't exceed 70 pounds each, per person. Most European carriers departing from the United States honor this luggage allowance for their passengers, as well. It is a different story when leaving from Europe, where bags must be approximately half that weight.

In country, if your safari involves flying from one game lodge to another, airlines will further restrict your luggage weight. Due to the small planes, they'll probably limit you to a strict baggage allowance of 33 pounds for both checked and carry-on baggage. That's less weight than some photographers' camera bags!

Since Mary Ann and I leave from the United States and use ground transportation throughout our trip, luggage limitations aren't a problem for us. We pack our clothing, tripods, and nonbreakable camera gear in three large, heavy-duty duffel bags. Our two largest duffel bags can weigh 60 pounds each, with the third bag reaching about 40 pounds. That's a lot of weight, most of which isn't clothing but tripods, ball heads, Groofwinpods, and other photo-related gear.

What to Pack

I'd like to assume that most people who embark on a photo safari are more interested in photography than fashion. Of course, what you pack is your decision, but fashion demands are pretty light on safari. Most parks and lodges don't require evening dress, although a very few, such as the Mount Kenya Safari Club, do maintain colonial tradition by requiring a coat and tie for men and skirts or dresses for women. However, dress codes are the exception, not the rule.

Regardless of the type and variety of your dinner and travel outfits, I suggest that you pack at least two changes of clothes for when you are in the field. This

Clothing Packing Tips

This is Mary Ann's basic clothing list for a safari. You might find it helpful when considering what you want to pack.

3 pairs of pants—2 for the field, 1 for evening

3 shirts—2 for the field, 1 for evening

T-shirts, underwear, socks—enough for about seven days afield

2 pairs of old sneakers—for the field

Sandals or shoes—for evening

Hooded sweatshirt, gloves, fleece vest—for morning game drives

Sun hat

Personal toiletries (see "Mary Ann's Travel Kit" on page 72 for specifics)

SUNRISE IN THE MASAI MARA
28–85mm F3.5–4.5 zoom lens, 1/60 sec. at f/11, Fujichrome 100.

Sunrise shoots can be surprisingly cool; it is best to dress in several light layers that you can shed progressively as the day warms up.

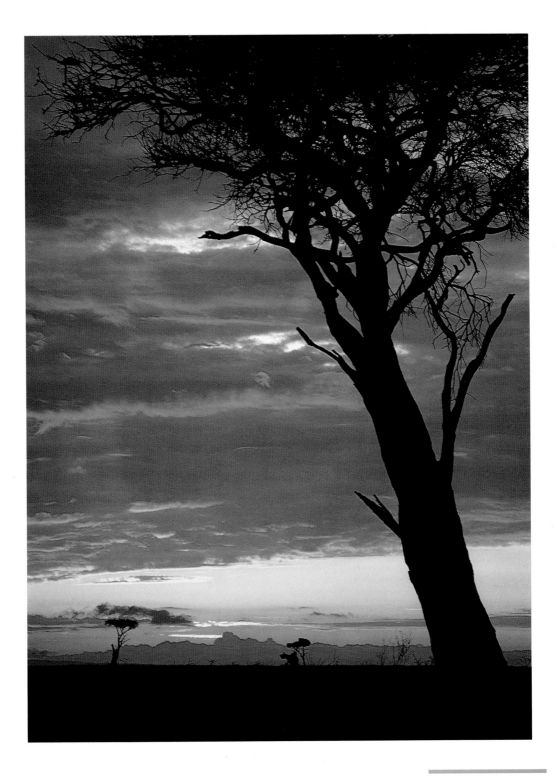

is probably a given for most people, although we've had a few folks. . . . Fortunately, most camps and lodges offer next-day laundry service at a very nominal cost. Bring along at least two pairs of shoes—one for the field, and one for evening.

You should plan on cool weather, too. It can be surprisingly cold standing in the roof hatch of a moving vehicle at dawn. On some predawn game drives, I've worn everything I had—windbreaker, hooded sweatshirt, vest, long-sleeve shirt, gloves, and wool cap or muffler. Cold-blooded Mary Ann often starts the day with a light pair of long johns, which she sheds during our breakfast stop.

The equatorial sun is intense, and it is wise to wear a hat and sunscreen to avoid sunburn. Safari vans typically have pop-up roofs, but most Land Rovers don't; either way there's a lot of reflected sunlight bouncing off the tops of these vehicles. A severe sunburn will certainly ruin your safari for a few days. Rain shouldn't be a major concern, but it is prudent to pack a nylon windbreaker or rain jacket for unexpected showers. It

There's no point in wasting luggage space by carrying film in its original packaging. Instead, I remove the film from the boxes and plastic containers, and pack 50 rolls of the same film type in gallon-sized Ziploc bags. In the field, I pack a day's supply of film in another gallon-sized Ziploc; within this large bag, I separate the film into sandwich-sized baggies according to ISOs.

usually rains in the afternoon or evening, so you shouldn't need rainwear on most of your game drives.

Most camps and lodges supply soap, and sometimes shampoo. All supply bath towels, but you might want to pack a facecloth, too. Voltage in Kenya and Tanzania is 220 (versus 120 in the United States), but your room or tent might have an electrical outlet for a direct 120 connection for electric shavers. Because of the wattage drain, hair driers, or similar heavy-duty appliances, require the 220 line, and you'll need a transformer to switch from 220 to 120 if you're using American-made products. RadioShack makes several types of transformers; hardware stores also often sell some. Pack a receptacle adapter since Kenyan outlets differ from those in the United States. RadioShack sells a travel pack that runs the gamut.

Going through Customs

Many people suffer needless anxiety about passing through customs. There are generic horror stories involving lengthy and exhaustive baggage checks, threatened confiscations, or demands for bribes, and undoubtedly, these stories, embellished in the retelling, are the basis of much of these fears. Most of the time, passing through customs anywhere is a breeze.

In all of my trips through Africa, Asia, and South America, I've only been hassled two or three times. Once, returning to Kenya from Tanzania, we were asked to empty our luggage for inspection; the official said he was looking for souvenirs, but in truth, I think he was just having fun at our expense to pass time on an otherwise uneventful day. We smiled, nodded politely, cooperated with the utmost enthusiasm, and thereby defused the overly zealous official. That's generally all that's required. On our most recent trip to Kenya, customs consisted of nothing more than presenting our passports and having them stamped. When our luggage finally showed up on the carousel, we were off.

You should be aware that airport authorities often X-ray luggage when unloading it from the plane, thereby eliminating the need for hand inspections. These X-rays can be more intense, however, than the

ones used for carry-on luggage, so I'd suggest that you don't pack your film in your checked luggage. In fact, I wouldn't check my film or critical camera equipment under any circumstance, for fear of losing it. I can always buy more clothes, and I can live without a tripod if I need to (since 95 percent of the photography is made from inside a vehicle), but I can't easily or economically replace my film or cameras. I always carry these items with me on the plane.

In general, most entries into foreign countries go off without a hitch, and those that don't merely require your complete cooperation. I suspect some customs officials, like our Tanzanian friend, enjoy giving tourists a hard time; it makes their day if you get upset or angry. You can't win. Just be agreeable and polite, even with the rare official who chooses to be difficult, and you'll have no trouble. Of course, I'm assuming that you have nothing to hide—to do otherwise in a foreign country is madness. Hakuna matata.

Medical Concerns

Road conditions aside, travel in East Africa is a relatively risk-free, benign experience. The threat of serious illness or disease is minimal, although you must still be careful. I strongly advise consulting with your personal physician or your local health clinic for professional advice and the latest information about your destination.

Most tourists are pleasantly surprised at the scarcity of biting insects in East Africa. Although I've picked off a few ticks while camping in the Ngorongoro Crater, and been bitten by my share of tsetse flies in acacia thickets, all told, I've been pestered by more bugs back home in Hoot Hollow, Pennsylvania. Still, Tanzania and Kenya do lie in malaria zones, and you must take precautions to avoid this serious, debilitating illness. Although repellents and mosquito netting prevent most insect bites, you only need one to develop malaria. Malaria pills prevent most strains of the disease, with dosages varying according to the medication. With Lariam, one of the most common medications, you take one pill a week starting the week before, and concluding four weeks

after, the trip. Your doctor can advise you on the possible side effects of this medication.

Many native Kenyans and Tanzanians don't take pills as preventatives; instead, they seek treatment if and when malaria develops. This is not the best route for tourists. Tropical doctors are attuned to malaria and its symptoms, but American physicians, who are unfamiliar with the disease, might misdiagnose your first malaria bout as a cold or flu. The consequences could be extremely severe.

Hepatitis, a minor threat, can be avoided with gamma globulin or a new vaccine that lasts for several years. You can prevent yellow fever, another mosquito-borne illness, with an inoculation. Tetanus, caused by punctures or wounds, is also preventable with a shot. The tetanus vaccine, by the way, is good for eight years and is worthwhile as much for home as it is for the tropics.

Years ago, an exotic vacation could turn a traveler into a human pincushion. Today, more diseases are being fought with pills, not needles, or at least with inoculations that last for several years. At worst, most injections cause flulike symptoms that last for only a day or two; often, there are no ill effects. Personally, I'm not bothered by the shots, save for a sore arm for a few hours.

As you probably know, AIDS and the HIV virus are a problem all over the world. As a virus, HIV is relatively difficult to catch, requiring transmission of infected bodily fluids. Sharing hypodermic needles, usually during drug abuse, or engaging in unsafe sex are the two principle ways of transmitting and catching AIDS. But, these should be easy to avoid for any clear-thinking tourist.

AIDS can also be transmitted through blood transfusions or contaminated needles used at health facilities. There is the risk that a severe accident or injury could require treatment that involves either transfusions or the use of hypodermic needles. Although most healthcare facilities are aware of, and take precautions against, the transmission danger, it is still a concern. To possibly lessen this risk, it might be prudent to know the blood types and Rh factors of your fellow safari participants, in case a blood

Mary Ann's Travel Kit

A veteran safarigoer, Mary Ann has developed a good travel kit and portable pharmacy over the years. You can use her lists as guides when you are deciding what you'll need.

Basic Items

Mary Ann considers the following things safari necessities, but you should feel free to add or delete items as you see fit.

Passport

International certificates of vaccination

Airplane tickets

Frequent-flyer card

Money belt

Pen and paper

Felt-tipped pen

Hat

Sunglasses

Extra set of eyeglasses or contacts

Binoculars

Bird or mammal field guides

Reading material

Inflatable neck pillow for airplane travel

Swiss Army knife

Jeweler's screwdrivers

Small sewing kit

Small scissors

Moist towelettes

Ziploc baggies

Large garbage bags

First-Aid Kit

Even the most basic items might be difficult to locate on safari, so it is best to bring them from home. Here are Mary Ann's suggestions:

Basic first-aid items (band aids, gauze, tape, first-aid cream, antibiotic salve)

Cold medicine

Personal prescription medications

Pepto-Bismol tablets

Imodium A-D or other diarrhea medicine

Malaria medicine

Tylenol, aspirin, or other painkiller

Benadryl cream or other hydrocortisone ointment

Benadryl pills or other antihistamine

Throat lozenges

Vitamins

Eyedrops

Sunscreen

Insect repellent

Soap

Toothbrush

Toothpaste

Dental floss

Feminine sanitary products

Hair products (try to do without a hair drier)

Tweezers

Cotton swabs

Cotton balls

Tissues

Safety pins

transfusion is necessary. It might also be wise to pack some disposable syringes for your personal use. Again, I suggest discussing these concerns with your own physician.

Many first-time safarigoers worry about the food and water in Africa and studiously avoid vegetables, fruit, fish, drinking water, and ice for the duration of their trip. Some of these people get sick anyway, while others, ignoring all precautions, never become ill. It doesn't seem to make sense.

I advise people not to drink tap water, even in cities, because it could be contaminated by some nasty bug that might cause gastrointestinal problems, such as upset stomachs or diarrhea. Even purified tap water poses problems because it has a high concentration of magnesium, which is guaranteed to keep you regular! I suggest that you buy bottled water, which is available at large grocery stores in town and also at the game lodges. It is probably impossible to avoid all contact with unbottled water; fruits and vegetables, tableware, and other assorted items are washed with tap water. You shouldn't worry about it—you'll either get sick, or you won't. I find that 1 out of 10 people on safari suffer some degree of stomach trouble, whether they're careful about the water or not.

In-Country Concerns

If you have the time, you should exchange money at the airport when you arrive in Africa or at a bank before you leave on your safari. The exchange rates will be slightly better in these places than at a hotel or game lodge in the field. Lodges take a commission and can limit how much money you can change. Exactly how much money you do exchange depends on your personal needs. I'd advise that you book and pay for everything before you arrive so that all your vouchers and reservations are in order and confirmed. If you cover those things in advance, it is quite likely you'll only be responsible for drinks, beans or rice for your beanbags, books, and other souvenirs. Most lodges accept credit cards for the purchase of souvenirs. If you're driving your own rental vehicle, you'll need cash for petrol, which is

much more expensive than American gasoline. You'll also need money for tips, but everyone will accept U.S. dollars for that.

After passing through customs, a representative of the tour company that booked your safari should meet you at the airport. This might be your driver/guide, or merely a taxi or courier to transport you to either your guide or your hotel. If you're traveling with a group, your tour leader will either be flying in with you or will meet you at the airport upon your arrival.

The driver/guide is, perhaps, the most important component of your safari, even if you have another, official leader for the organized tour. Your driver knows the country, the roads, the other safari guides who you'll meet along the way, and the likely spots for particular animal sightings. An enthusiastic, responsible, and ethical driver makes your safari a fantastic experience, while an unscrupulous one can turn it into a journey to hell.

Your relationship with your driver is extremely important. On the one hand, you should consider your driver as being in your employ, and he should be open and agreeable to your wishes and goals. On the other hand, it is also true that you're at your driver's mercy because he can follow your directives to the letter and, in doing so, guarantee that you'll never film an animal. For example, following your orders, he might drive to the left even though he knows, from his conversations with other drivers in the field, that an animal lies behind a rock outcropping to the right. He might intentionally get your vehicle stuck in a mud spot that he could easily have avoided. A driver who dislikes you, or feels that he's being rudely ordered about or mistreated, can make all the wrong moves yet put on such a believable amiable act that you'd never guess you're constantly being had.

To avoid this, consider your driver a member of your team. You can make suggestions regarding what you'd like to see or what you hope to photograph, but don't give orders, and don't tell the driver where to go unless you truly know what you're doing. If it is your first trip, go light on the directions. I've seen

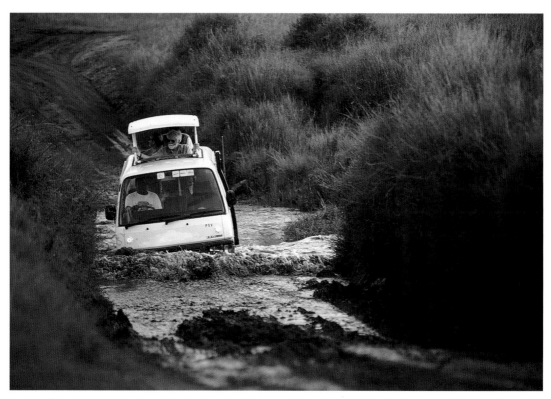

TOURIST VAN CROSSING DRY WASH

Our van had successfully passed through this depression in the past, so I knew it was possible. Still, I often wonder if drivers consider all the options in the event that they start across and aren't able to make it. Perhaps it's best not to think about it.

many television-educated travelers attempt to run a safari based on data they gathered from nature and wildlife documentaries. While that information might be valid, these television shows aren't made on two-week safaris. Documentaries, which require several months or years to film and then compress all that footage into an hour-long program, paint an unrealistic picture. Drivers resent a know-it-all and will express their resentment by quietly letting that person direct them, even if it is in the wrong direction.

I'm familiar enough with many of Kenya's parks (knowing where I'm likely to find leopards, cheetahs, or any other species) that I could drive myself. Still, when my guide asks me where I'd like to go, my

usual response is, "Wherever—you know what I want. Let's just have a great game-drive!" Or words to that effect. My driver knows whether we've had good lions, or seen enough cheetahs, or had our fill of leopards (which never happens) or activities at kills. I can trust him to find the best sightings. You're not likely to have this type of relationship on your first few safaris, so I'd suggest sitting down with your driver at the first opportunity to explain your goals. Let him know what you hope to photograph and what your level of patience is so that he can customize your trip.

Many drivers are conditioned by the average tourist who likes short game drives but wants to "see

*A pride of lions
feeding on a buffalo
drew hordes of people
and culminated in this
traffic jam. However,
when we returned the
following morning, we
had the lions all to
ourselves.*

everything," especially the "big five": lions, leopards, rhinoceroses, buffaloes, and elephants. To these drivers, 20 minutes watching a lion feeding on a kill might be a sufficient amount of time, while three hours waiting for a cheetah to resume stalking a Thompson's gazelle might be unheard of. So, you should try to let your driver know what you'd like to see.

Vehicle Concerns

If you're driving yourself, your principal concerns should be avoiding getting lost or stuck, and finding game and getting close enough for good filming. Of course, if you're taking a private safari, you eliminate all these matters, and as I said before, if you make sure your driver knows your objectives, things should go smoothly.

If you're on a tour, the tour leader will explain the trip objectives to the drivers. Hopefully, your leader will devise a fair seating arrangement so that everyone has a chance at the prime seats, and to shoot with the professional-photographer leader, if one is along. Some tours assign participants to a specific van and driver for the duration of their safari; others rotate everyone throughout all the vehicles. If these points are important to you, find out what the arrangements are from your tour leader before you sign up.

Unless you have a vehicle to yourself, one of the most important aspects of safari shooting is vehicle etiquette. There's a definite need for group cooperation if everyone, or anyone, is to get sharp pictures. Movement inside a vehicle makes good shooting difficult. My suggestion is that everyone in a vehicle make an agreement regarding movement: If people are photographing and someone must move to change film, cameras, or lenses, some warning should be given or permission asked. I think it is reasonable for you to say, "Can I move?" when you need to; this way, if a good photo opportunity is about to occur, those sharing your vehicle can say, "No! Please wait." After all, if you must move, you're out of position anyway, and by rocking the vehicle, you will ruin the shot for anyone who is prepared.

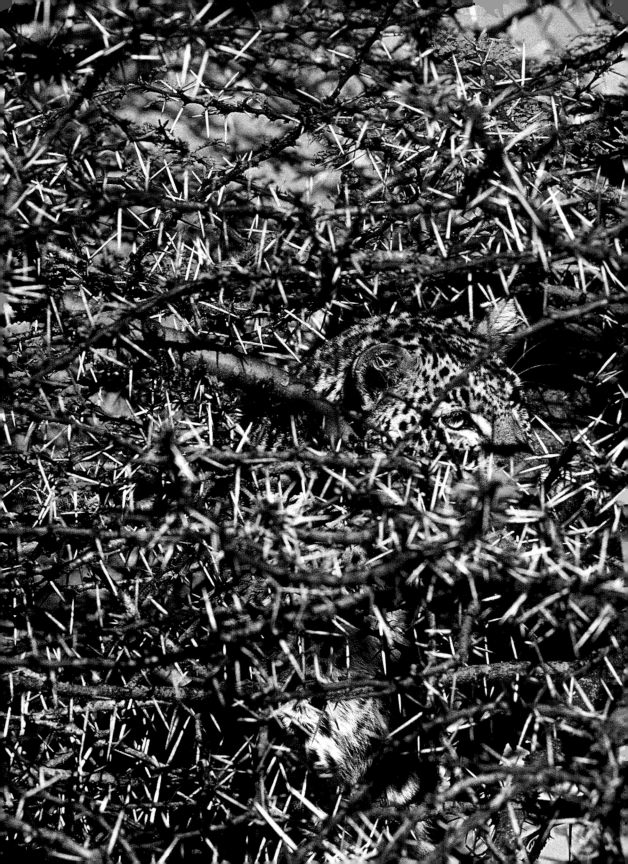

Shooting Strategies

FOR MANY OF US, just being close to an animal, let alone having the chance to observe its behavior and document it on film, is a privilege. With this excitement, some photographers lose their objectivity, making terrible pictures simply because a lion or an elephant stands before them. Others miss the best shots because they aren't prepared when that ultimate photographic moment occurs. Knowing when to shoot, and being ready for that occasion, is the key to successful photography. Even though I cannot help you control your excitement—and indeed I hope this book promotes it—I can prepare you for many of the opportunities that you'll encounter.

CAMOUFLAGED LEOPARD IN ACACIA TREE

Believe it or not, there's an adult leopard in this tree! Although this is certainly not the definitive leopard portrait, it clearly illustrates how difficult it can be to locate these elusive animals.

The Big Cats

East Africa is home to three big cats: lions, leopards, and cheetahs. While the abundance and variety of big cats vary from park to park, you're quite likely to photograph two of the three cat species, namely lions and cheetahs, on any two-week safari. Both lions and cheetahs are fairly common and usually very cooperative, often surprising photographers with their nonchalant manner. Note that it is extremely rare to have the cats actually look at you—they almost always look past you as if you aren't there. In fact, if you're too close, cats will stare into space as a way to relieve the stress.

As the top predators in the African food chain, the three cat species do not coexist in a peaceable kingdom. Lions will kill adult or baby cheetahs or leopards if they have the opportunity; likewise, leopards will kill and eat baby lions or cheetahs. And cheetahs—well, they usually just try to stay out of harm's way.

Some key photographic moments will be easy to recognize, as the cats, like many animals, telegraph their intentions; set ears, an intense look or body posture, the appearance of another animal nearby, or some other clue can alert you to imminent action. Sometimes, however, there is no warning for that one second that makes an incredible shot.

The big cats can be disappointing, however, because all three species spend an incredible amount of time doing nothing. If you don't have the patience to wait, you might easily record nothing but sleeping bundles of fur in the grass.

Although I don't always practice what I preach, I recommend that you keep your eye to your viewfinder and be ready to shoot as long as you're with any game. Too often, I've been caught with my guard down when an animal suddenly did something extraordinary. In this chapter, I'll describe the actions and behaviors of many of the cats, other mammals, and birds that you're likely to see.

African Lion

For most people, the African lion is the most sought-after photographic safari subject—the symbol of Africa and its wilderness. The lion is the only social cat, living in family groups, called prides, which are composed of several related females, their young, and

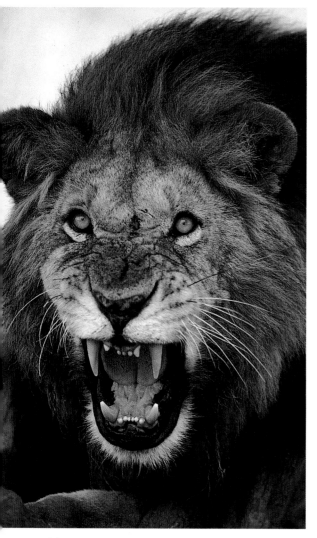

MALE LION SNARLING
500mm F4 lens, 1/250 sec. at f/4, Kodachrome 64.

This lion was warning another to stay away from his kill.

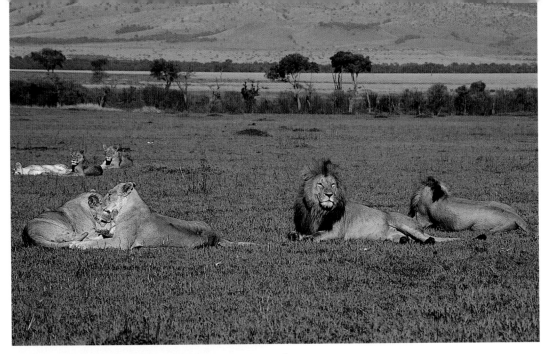

LION PRIDE
80–200mm F2.8 zoom lens, 1/125 sec. at f/11, Fuji Velvia 50.

Lions are most active at night and avoid open areas during the heat of the day. Shortly after I took this shot, this pride disappeared into a thick, brushy lugga (a naturally formed ditch).

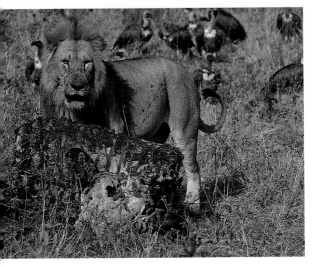

MALE LION WITH KILL
500mm F4 lens, 1/500 sec. at f/8, Fujichrome 100.

A meal doesn't last long in the savannah. This male, filled to bloating, still guards this carcass from the hyenas and vultures that wait nearby. Within two hours from the time he finally left and the scavengers took over, nothing remained but a bare skull and a row of backbones.

one or more adult males. Prides can number from as few as 2 or 3 to as many as 30 or more cats of varying ages. A safari without a lion sighting is a major disappointment, and although unlikely, this is a possibility. So, don't take this cat, or its abundance, for granted.

Lions spend as much as 20 hours a day sleeping. Most are active in the first hours following dawn, the last hours of the day, and during the night. In the morning, you can find lions feeding on kills that they made in the darkness, or heading toward cover where they'll spend the day. In the late afternoon, activity resumes when the pride wakes up. You can expect yawns, greetings involving head butts or mutual grooming, and long stretches.

Lions are consummate opportunists. Even when well-fed or sated, lions often hunt if an animal wanders too close—even at high noon, peak sleeping time. When prey is scarce, lions hunt whenever a

chance presents itself. Watching a hunt is incredibly exciting because no two are ever the same. If possible, the lions fan out and circle their prey to force the fleeing animal to run into one of them. They'll hunt any prey, from small mongooses to large, adult giraffes, but they seem to favor gnus.

During the gnu migration in Kenya's Masai Mara, kills are frequent, but most occur at night. You're more apt to witness a diurnal hunt when prey is scarce, so consider this when scheduling your safari. If you're interested in filming hunts, visit prime lion locations, such as the Masai Mara, Serengeti, or Ngorongoro, when the large herbivores have migrated elsewhere.

Although a hunting lion might use a vehicle as a blind when it approaches its prey, don't try to follow the lion or get between it and its prey. You will ruin the hunt if your vehicle moves too close and frightens the animals off. I've also seen overly enthusiastic drivers trying to herd gnus or zebras toward a waiting group of lions. This unethical action doesn't work because the unnatural occurrence of the prey running toward them (with vans in tow) confuses the cats into inaction. Watch from a distance, don't interfere, and if you're lucky, the hunt will proceed within your view.

Activity at a kill, as lions feed or grapple for positions, can trigger growls or roar-filled tussles. A noisy group of feeding lions also often attracts hyenas, jackals, and vultures, providing great shots when the nearly sated lions leave the kill to drive off scavengers. Occasionally, the cats will catch a hyena or a vulture, but usually you'll just film a short chase. The lions eventually tire of this game, or of being in the sun, and abandon the kill to the scavengers.

One of the more exciting scenes you might photograph is a pair of honeymooning lions—an actively mating pair. At the peak of their heat, lions mate several times an hour, perhaps even as frequently as every five minutes. Mating is characterized not only by the obvious, but by a snarling, swatting session at the conclusion of each round. This action is a prime photographic moment.

There are several other behaviors worth noting. If you see one lioness approaching another, get ready—chances are they'll engage in some type of greeting ceremony. Cubs are continually active when awake. They play with the adults' tails and engage in mock-hunting, pouncing on the backs of passing cats, and this often triggers wrestling matches. Nursing is interesting but can be difficult to film because the cubs snuggle tightly against their mother's belly.

In many areas lions are quite habituated to vehicles, and it is easy to get within an 80–200mm range for full-body portraits. Tighter shots require longer lenses, but working distances within 50 feet are entirely likely. Lions are a middle tone in color, except around the male's mane. You'll get an accurate meter reading right off the hide using any exposure mode.

LION CUBS
500mm F4 lens, 1/125 sec. at f/4, Lumiere 100.

If a cub is awake, keep watching it! Chances are good that it will make some mischief, either with a sibling or with a tolerant adult.

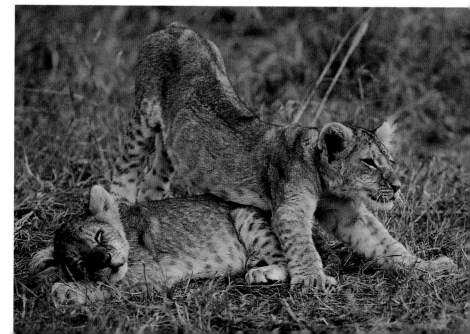

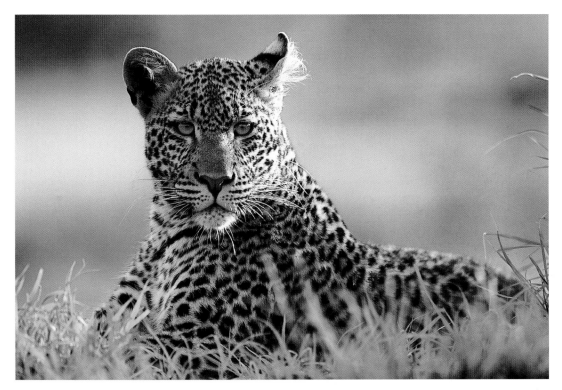

Leopard

The leopard is the trophy cat. Once threatened with extinction because of a fashion craze in spotted furs, the leopard is again fairly common. Still, this big cat is quite difficult to find. Its fur provides superb camouflage, enabling it to blend in to its surroundings to near invisibility, whether it is lying in tall grasses or sprawling across an acacia limb. Sighting one, and then getting close enough to look into its baleful, green eyes, is the highlight of most safaris. Perhaps because of their elusiveness, leopards make exciting subjects, even when they're doing nothing. Active leopard behavior is more difficult to observe than that of other big cats because leopards frequent thick cover (trees, bushes, brush, etc.) and are the most animated at night.

Still, there are a few shots to watch for. For example, in many areas leopards hang their kills in trees; this keeps the food out of the reach of scavenging hyenas and the feeding leopards themselves safe from marauding lions. If you find a fresh kill, it

LEOPARD
600mm F4 lens, 1/250 sec. at f/4, Fujichrome 100.

Usually shy and retiring, leopards in some areas are remarkably comfortable with vehicles. Shortly after this photograph was taken, one of the young cats was killed by a lion.

is possible that the leopard is nearby and might return while you're waiting.

Leopards generally hunt alone and at night, but like lions, they'll kill whenever they can. I often find this secretive predator by observing the actions of nearby herbivores. Impalas, waterbucks, monkeys, and giraffes often alert me to the presence of a leopard. For example, impala herds adopt tense postures and all face in the same direction. I've also watched waterbucks and giraffes advance toward a leopard, contradicting the expected timid herbivore behavior. Prey animals have little to fear from a predator they can see, so they're likely to advance and follow a

leopard or cheetah to keep it in sight. This alert posturing by prey animals is a good indication that something of interest is nearby.

On rare occasions, I've filmed leopards with their cubs or feeding on fresh kill in the grass. These sightings are so infrequent and unpredictable, however, that it is impossible to provide tips on how to photograph them, except perhaps to caution you to approach slowly so as not to frighten off the cats.

When it comes to leopards, you just have to rely on luck and the excellent vision of your driver. If you are lucky enough to find a leopard, take some insurance shots from a distance first, before you try to move in. You should close down your aperture because the black spots of the leopard fur can trick your meter into overexposing, and if possible, take a reading from the cat's snout, or a middle-tone area that's in the same light as the cat.

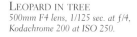

LEOPARD IN TREE
500mm F4 lens, 1/125 sec. at f/4,
Kodachrome 200 at ISO 250.

We discovered this resting leopard at the very end of the day. Luckily, everyone in my van was fairly still, enabling me to use a long lens with a slow shutter speed in the dim light.

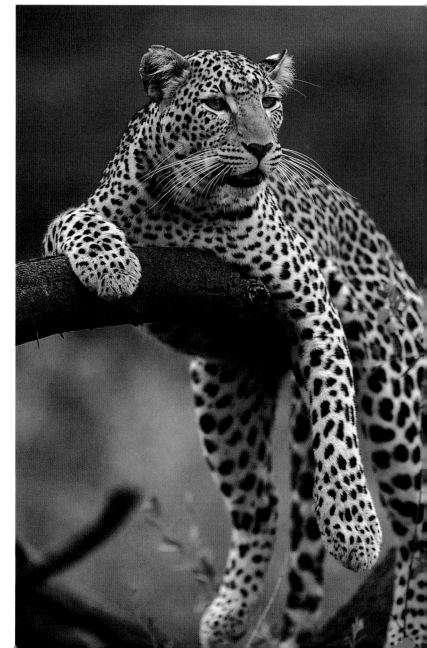

Cheetah

Built like a slender greyhound, the cheetah is the fastest land animal, capable of running at speeds of up to 70mph for short sprints. As a predatory lightweight, cheetahs specialize in capturing the smaller, fleet-footed antelopes of the open plains. Cheetah brothers often stay and hunt together as adults and can take larger prey, such as small gnus or zebras; female cheetahs, in contrast, lead solitary lives, except when they're raising cubs. Cheetahs often hunt at midday, when it is less likely that the larger, more aggressive predators will be about to steal their kills.

Where cheetahs are common (in the northwestern Masai Mara, for example), it is quite possible to see one hunting, feeding, or even making a kill. A hunting cheetah will travel for hours, covering the same few kilometers as it seeks out a potential victim.

Also, watch for lone trees in the cheetah's path. A cheetah might stop to mark its territory there by spraying urine and might also spend some time sharpening its claws. Cheetahs often climb small, well-branched trees and use them as lookout posts. If you see a likely tree, drive ahead and be there waiting.

Mothers and their cubs make appealing subjects. Since cheetahs are most energetic during the day, there's often plenty of action in good light. Cubs can be very animated, playing with, wrestling, or chasing one another or their mom. As the cubs grow, the mother captures small prey, such as gazelle fawns, to train her young to hunt; she will stun the prey by suffocation, then release the dazed animal in front of her cubs. As the animal recovers and attempts to escape, the young take chase. In this way, they learn to kill.

Of the three African big cats, the cheetah is the least numerous, but because of its diurnal habits and its open habitat, you will probably see it about as frequently as the lion. Most are fairly approachable. In the northern Masai Mara, they are extremely habituated to humans; one family group even uses the roofs or hoods of vehicles for spotting game.

As with leopards, a cheetah's black spots could bias your meter reading. If you can, take a reading off the cat's face, which has fewer spots, or off a nearby middle-tone area. Some adult cheetahs are a bit lighter than a middle tone, so for these cats you should close down off the middle-tone reading by 1/3 stop. Very young cheetahs are almost black with silvery-gray manes; to correctly meter them, meter the mother's face, or a middle-tone area, and use that exposure.

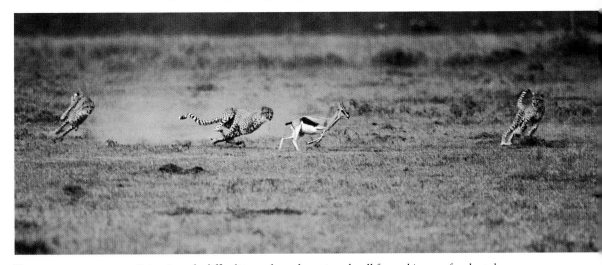

HUNTING CHEETAHS
500mm F4 lens, 1/500 sec.
at f/5.6, Kodachrome 64.

It is extremely difficult to make a close-up and well-focused image of a cheetah chase. Conditions must be perfect: the animals must be fairly close to you, and as the chase begins, they must run toward you.

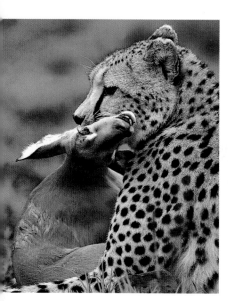

CHEETAH WITH IMPALA FAWN
*600mm F4 lens, 1/250 sec. at f/4,
Fujichrome 100.*

*It is always a compositional
challenge to crop a subject that is
close by and lying broadside to you.*

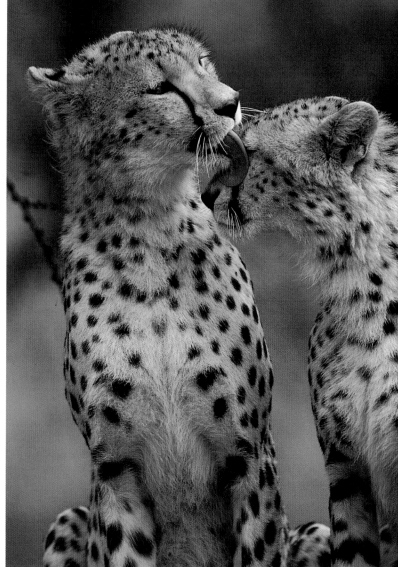

GROOMING CHEETAHS
*600mm F4 lens, 1/250 sec. at f/4,
Fujichrome 100.*

*After finishing their kill, these two
cheetahs spent the next several
minutes grooming each other.*

CHEETAH CUB
*500mm F4 lens, 1/125 sec.
at f/5.6, Kodachrome 64.*

*While cubs are undeniably cute,
it can take several hours of
waiting and filming before one
adopts an interesting pose.*

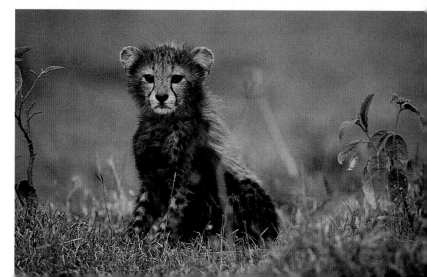

Other Predators

Besides the big cats, East Africa is home to several other predators. Some of these, such as servals, caracals, and African wild cats, are infrequently or rarely seen. Others, such as the hyena and jackal, are often dismissed merely as scavengers. However, both are effective, deadly hunters in their own right. Still another, the African wild dog, is the most efficient of all the predators. It is successful in 90 percent of its hunts, compared to about a 30-percent success rate for a pride of lions. Its prowess and method of capturing prey has earned the wild dog a fatal reputation; for years it was killed whenever it was found.

Jackal

You'll find three species of jackals—black-backed, side-striped, and golden—in the region. The black-backed is probably the most common and the one you're most apt to photograph. Although jackals often hunt on their own, they usually frequent kills or carcasses. In the scavenger pecking order, jackals are near the very bottom—sometimes they can drive a flock of vultures off a kill, sometimes they can't. They're fast and agile, often stealing tidbits from kills when hyenas and lions are still present, but they're also quick to sprint off at the first sign of danger.

Despite this, jackals are opportunistic predators, and as Thompson's gazelles fawn, jackal pairs course the savannah for hidden young. They will chase and capture any injured adult or female gazelles that are acting as decoys to keep the jackals from the fawns. I find most jackals to be fairly shy, so it is best to drive into position (and stay put) as soon as you see one approaching a kill. If you wait and try to move in later, chances are you'll frighten it away; in general, it is wise to keep your distance and use your longest lens.

Jackals bear young throughout the year in a burrow they generally dig themselves. The young are curious, and will pop out of a burrow to play if you just wait long enough. It is helpful to be quiet—and if you're traveling in the company of several vans, you should all stay put until there's action. This is

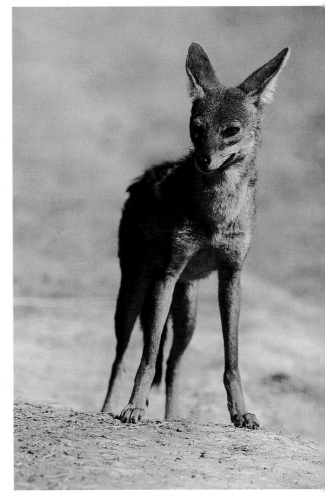

BLACK-BACKED JACKAL
500mm F4 lens, 1/250 sec. at f/5.6, Kodachrome 64.

Jackals can be very shy, and you'll probably have your best luck sighting them around kills, where they gather to steal scraps.

frustrating because stationary vehicles usually attract parties hoping to see big cats; the newcomers generally don't stay once they realize there are no cats, and the constant traffic keeps the young jackals inside their den.

Regardless of the species, the golden-brown fur on a jackal's side is a good middle tone to meter.

Spotted Hyena

Few animals have as sordid a reputation as the hulking, skulking hyena. For many years, we thought that these aggressive animals existed solely by scavenging, but later, nocturnal research revealed the hyena's role as a deadly, efficient predator—the wolf of the night.

You can often find hyenas at dawn returning to their dens. When prey is scarce, they can be about at any hour. You will frequently see them around lion kills, where, unless they outnumber the larger predator, they will patiently wait their turn. As a matter of fact, in some cases hyenas make the kill but are driven off by lions and must wait for the scavenging cats to leave! When times are lean, though, a mob of hyenas will drive lions and other big cats off a carcass. At kills, hyenas often show up last, and their arrival makes for wonderful shots when they charge in and scatter hovering vultures.

Hyenas are true opportunists, and will kill whenever the chance arises. Once, I watched a hyena and her half-grown cub chase a herd of gnus several hundred yards before finally grabbing an adult and stopping it dead. This event, though action filled, is certainly not for every nature enthusiast.

Hyenas do make interesting and appealing subjects when away from kills. Since they're fond of soaking in shallow pools during midday, it is fairly easy to get close enough for full-body shots. Also watch for nursing, young at play, and social displays. When hyenas return to a den, they go through an elaborate greeting ceremony, sniffing one another, nuzzling, and sometimes play-mobbing any young that are near.

Adult hyenas are middle tone, or slightly darker than middle tone, in value. Generally, a spot-meter reading off the lightest area of the hyena will yield a proper exposure. Or, you can meter a middle-tone area that's in the same light. Young hyenas are almost black, so to meter them either read off the adults or off a middle-tone area and overexpose by around 1/2 stop. Don't overexpose by very much, however, unless the young nearly fill the frame.

SPOTTED HYENA
*600mm F4 lens, 1/250 sec. at f/6.3,
Fujichrome 100.*

Shooting from the lowest perspective possible, I framed this hyena against a pleasant background of blue sky.

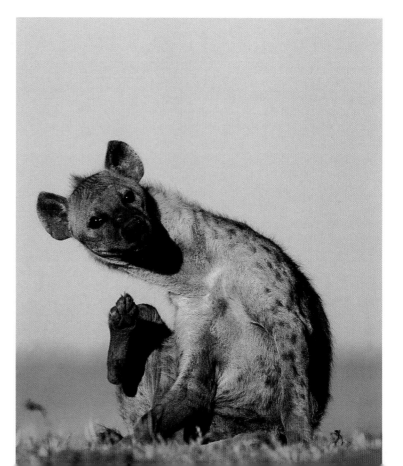

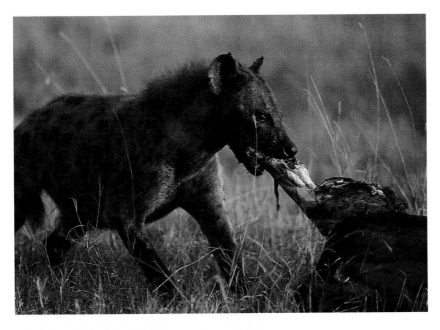

You should never be without fast film on any game drive. It enabled me to capture this lively image.

African Wild Dog

This active canine is one of the most appealing, and misunderstood, African predators. Despite their name, wild dogs (which are sometimes called Cape hunting dogs) are not related to feral dogs any more than a fox is to a wolf (they are a different genus).

They're small, weighing about 40 pounds as adults, and they run down gnu calves, impalas, topis, and larger prey in packs ranging from 6 to 30 animals. They stop an animal with crippling bites to its hamstring, or by latching on to its snout while other members of the pack bite the animal until it falls. This method of hunting fostered tremendous antipathy toward wild dogs, and for years people shot them on sight or poisoned them.

Today, in parks at least, they enjoy complete protection, although they now face a new menace—

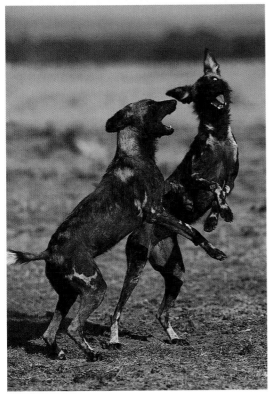

AFRICAN HUNTING DOGS AT PLAY
300mm F2.8 lens, 1/250 sec. at f/8, Kodachrome 64.

A very social pack animal, wild dogs spend a great deal of time playing, which reinforces the important family ties that are necessary when hunting large animals.

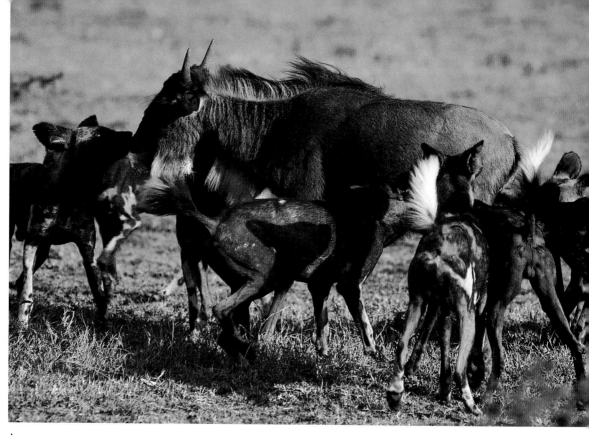

AFRICAN WILD DOGS ATTACKING GNU CALF
300mm F2.8 lens, 1/250 sec. at f/8, Kodachrome 64.

Hunting in groups, wild dogs are capable of hauling down game several times their own size. Since hunts can last for hundreds of yards, or even miles, it is difficult to be at the site of a kill when the dogs finally do catch their prey.

illness. Wild dogs are susceptible to the same diseases as domestic canines, and entire packs and even park populations have been wiped out by distemper or rabies. They are an endangered species throughout their range, so count yourself extremely fortunate if you encounter any in East Africa. The largest groups now reside in the parks in southern Africa.

In East Africa, it isn't likely that you'll have the chance to film dogs at their den, but the action there is outstanding. Dogs are wonderful parents, playing with their young and regurgitating food when they return from a hunt. Away from the den they're fairly inactive, except when they hunt, which is either early or late in the day when the temperatures are coolest—this makes the long chases less taxing. Should you encounter dogs at the end of a morning game drive, it is quite possible that they'll stay close to that same location for the remainder of the day. So, you can return late in the afternoon to check on their activity. Evening hunts generally start within an hour of sunset, and are usually preceded by play behavior that seems to excite the pack members into action.

Wild dogs vary greatly in color. Some are tan, others nearly black, but most are a piebald combination of white, tan, and black. You'll have the most success metering exposures off the lightest nonwhite patch, or another a middle-tone area.

Bat-Eared Fox

This cute, coal-gray, gnomelike creature is the smallest canine that you'll encounter on safari. It uses its huge fanlike ears to locate insects beneath the soil, but it is unlikely that you'll see one hunting because they are mainly nocturnal. Bat-ears are most common in the grassland parks—the Serengeti, Ngorongoro, and Masai Mara—and in semiarid areas such as Samburu and Meru National Park.

You might sometimes see bat-eared foxes on your early morning game drives because this is when they return to their dens after the night's prowl. Foxes that are unaccustomed to vehicles generally run, although you might find one or two that simply lie still in a protective huddle. In late afternoon, foxes sometimes appear at the entrance of their dens, providing further portrait opportunities.

Because these little foxes are darker than a middle tone, take a meter reading off a nearby middle-tone area, and go with that. Use the longest lens you have to reduce the chances of spooking this nervous creature.

BAT-EARED FOX AT DEN OPENING
500mm F4 lens, 1/125 sec. at f/4, Kodachrome 64.

These foxes spend their days in burrows. If you find a den, wait quietly near its entrance. If you're lucky, your patience will be rewarded.

Mongoose

Although there are several species of mongooses in East Africa, you'll probably film only two—the dwarf and the banded. These golden-eyed, sleek animals are social and live in groups ranging from 5 to 15 individuals for the dwarf, and 10 to 30 for the banded.

Of the two, the dwarf mongoose is the more cooperative subject. Watch for it around termite mounds. Usually, the group will retreat into the burrows and tunnels of the mound as you approach. Then, depending on their degree of habituation to humans, they may pop up almost immediately, or they may wait several minutes. Once one gains enough confidence, it is likely that the whole group will materialize, weaving in and out of holes.

Banded mongooses are more difficult to photograph, even though you'll see them (usually galloping en masse across the grasslands) more often than you'll see the dwarf variety. When you follow them by vehicle, the group might duck into a termite mound or warthog burrow and remain hidden or dart, either singly or in pairs, to new shelter a few minutes later. I've rarely seen banded mongooses remain still for very long.

Both mongooses are darker than a middle tone. Meter a middle-tone area around the mongoose and use that reading, letting their darker tones fall into place (or register as a darker tonality). If you're too close, they'll stay underground or run, so use your longest lens.

DWARF MONGOOSE
500mm F4 lens, 1/500 sec.
at f/5.6, Fujichrome 100.

The late afternoon sunlight on the termite mounds cast strong shadows, which provided interesting relief in this composition. I metered the brightest area of the mound, since the mongoose was darker than a middle-tone value.

Grassland Primates

About a dozen species of primates, including chimpanzees, gorillas, baboons, and monkeys, inhabit East and central Africa. Photographing chimps and gorillas requires special trips (involving special permits and travel to other habitats), and I won't cover these animals here. You might encounter other monkeys, including colubus, blue, and Syke's, in forested areas, but it is unlikely that you'll have many opportunities for this. You should expect to photograph only two types, the olive baboon and the vervet monkey, on most safaris. Both species can be incredibly tame, to the point, actually, of being a menace around game lodges.

Olive Baboon

Adaptable, cunning, and aggressive, baboons are the most common primate of mixed woodland and savannah areas. Baboons generally travel in troops ranging from a dozen to 60 or more members, and they flank out in a wide front to search for plants, seeds, and small animals. They are very social, and their interactions with one another make great photographs. A few of the shots to look for include mutual grooming, where baboons comb through and pick at each other's fur or scalp; scratching, often involving outrageous postures and positions; and a variety of mother-and-baby interactions.

OLIVE BABOON
300mm F2.8 lens, 1/250 sec. at f/5.6, Fujichrome 100.

Cloudy but bright light is ideal for most mammal portraits, especially of baboons, since in harsher light their brow ridges can cast sharp shadows over their eyes.

OLIVE BABOON WITH BABY
500mm F4 lens, 1/500 sec. at f/5.6, Fujichrome 100.

Baboons are very animated subjects, rarely holding still long enough for you to get more than a few images of any one pose.

Baboons are very attentive to their young. Most members of the troop greet and investigate any pink-faced newborns, and the older youngsters play together animatedly. Several dominant males protect the troop and enjoy the fawning attention of their subordinates. A large male is quite formidable, with a doglike muzzle and huge canine teeth that enable him to inflict serious wounds. I've often seen baboons chase cheetahs for hundreds of yards, and I once saw a leopard flee for its life when a large baboon troop surprised it in the tall grasses.

Baboons are the major pest around the tourist lodges, searching open tents and cabins for anything edible. I've often watched tourists chase baboons across camp, trying to reclaim items that the animals pilfered from suitcases. In the open-air dining areas at some lodges, I've even seen baboons leap into the center of a dinner table to steal from people's plates! At one lodge, I watched a terrified couple sprint to their cabin with a pair of big males in close pursuit. If you're tempted to feed a baboon, you're only inviting trouble.

These primates are darker than a middle tone in value, so take a meter reading off a nearby middle-tone area. The baboons' heavy brow ridges hood their dark eyes in shadow except in low, angular light; to catch an eye highlight, plan on shooting baboons either early or late in the day, when the sun is low in the sky, or use a flash to pop a sparkle in their eyes.

Vervet

Of the several species of monkeys found in East Africa, the handsome vervet is the most widespread. It is also the easiest to find, inhabiting much the same area as olive baboons. It often comes as a surprise to find a vervet out in the open; you just don't expect to see monkeys hundreds of yards from the nearest trees. Vervets are occasional pests around lodges, too, but because of their size and temperament, they don't pose the problems that the baboons do.

Like all monkeys, vervets are social, and some of your best images might involve mutual grooming, inspection of newborn young, and play behavior. Activity takes place either on the ground or in trees, as vervets are equally at home in both. Sometimes called green monkeys, vervets are frequently greenish-gray in color. The back and side of a vervet provides a good middle tone for metering.

VERVET MONKEY
300mm F4 lens, 1/250 sec. at f/5.6, Kodachrome 64.

You can often spot vervets sitting in trees.

VERVET MOTHER AND BABY
300mm F2.8 lens, 1/125 sec. at f/4, Kodachrome 64.

Mothers with babies are especially alert; you should move very slowly to keep from frightening them off.

Hoofed Mammals

Quite literally, Africa's herbivores are the "meat" of any safari, providing food for the predators and innumerable subjects for photographers. They occupy almost every possible habitat, from lake to desert, and include such familiar species as zebras, giraffes, buffaloes, pigs, rhinoceroses, antelopes, and hippopotamuses. Among the antelopes alone there are well over 30 species, although you're only likely to see a dozen types or so on your safari. However, you might see them in groups of hundreds or even thousands. In the following section, I describe the species that you're most likely to encounter at the most frequently visited parks.

Oddly enough, many herbivores are difficult to film. Unlike the confident predators, who are used to humans simply because of the sheer number of photographers seeking them out, herbivores are, or seem to be, shy. While many herbivores completely ignore vehicles that drive close by, most wander off, presenting their backsides as soon as the vehicles stop. This happens constantly and will eventually wear down your patience and enthusiasm. The result: at safari's end, you'll have plenty of shots of elephants, giraffes, and big cats (if you're lucky), but few good images of the most abundant animals, the antelopes. Photographing many of the herbivores does require a certain tenacity, but if you persevere, chances are you'll obtain great shots of every subject you encounter.

Grevy's Zebra

What color is a zebra? Black with white stripes, or white with black stripes? The Grevy's zebra may provide the answer—it has narrow black stripes that terminate at its white belly. For my money, zebras are white.

GREVY'S ZEBRA FOAL
500mm F4 lens, 1/250 sec. at f/5.6, Fujichrome 100.

For this tight shot I concentrated on the foal, including just enough of the mother to suggest what's happening.

RESTING COMMON ZEBRAS
300mm F2.8 lens, 1/250 sec. at f/8, Fujichrome 100.

The sun was slightly behind this pair of resting zebras, thereby reducing the otherwise troublesome contrast.

You'll find Grevy's zebras in the semidesert habitats of northern Kenya, and also at the Samburu-Buffalo Springs Game Reserves and Meru National Park. They form small herds of 5 to 30, usually mares with their young, and a dominant stallion. They aren't very animated, but their attractive patterns make up for this. And, believe it or not, they work out pretty well as middle-tone subjects. Simply meter directly off the animal, or some middle-tone earth or grass in the same light.

Common Zebra

The larger herds and broader distribution of this species provide greater shooting opportunities than the Grevy's zebras. Challenges by intruding zebras can lead to vicious fights characterized by kicking, rearing, and leg-biting. Common zebras are very social; they often groom one another and, when resting, will set their chins on one another's backs with heads facing in opposite directions to watch for danger. This pose makes a great shot, as do tight compositions of zebra stripes in abstract patterns. Common zebras often accompany gnus on their migration. On several occasions, I've filmed river crossings composed of both gnus and zebras, and of just zebras alone. Exposures for the common zebra are the same as for Grevy's.

Dik-Dik

These beagle-size antelopes are the most common of the smaller species. In many habitats, you're apt to find them around the open areas near thick cover. Dik-diks either stand motionless or run off when they first see you, but if they aren't alarmed, they'll usually provide a few minutes of shooting before they move back into cover.

Dik-diks make territorial dung heaps, or middens. Although this activity might not appeal to you photographically, a dung pile does indicate that there are dik-diks in the area. This animal also marks territory by rubbing a preorbital scent gland, a wet-looking spot at the forecorner of its eye, on twigs or grass blades, and this behavior is a bit more photogenic. Dik-diks are good middle-tone subjects, and a direct meter reading off their fur produces good exposures.

Gnu

Zoologists have described this strange-looking antelope as an animal designed by committee, with the head of a goat, the horns of a cow, and the body of a horse. Also called the wildebeest, white-bearded gnus are best known for the incredible migrations they undertake each year. In February, herds of gnus travel to the Serengeti plains to give birth. Here, most gnus drop their young within a three-week period, providing a food glut for the Serengeti predators (although only a small fraction of the total number of young are ultimately killed). This mass birthing is critical for a herd's survival; it is estimated that nearly 100 percent of the young born outside of this peak birthing period are consumed by predators.

When the dry season arrives, the gnus leave the Serengeti, traveling in a roughly clockwise path that can lead to the uncropped grasses of Kenya's Masai Mara. The breeding season, when male gnus go through an elaborate courtship display of jumping in circles and fighting, coincides with the start of this migration. The migration doesn't reach the Masai Mara every year, and when it does, it isn't always at the same time. Generally, though, the gnus move into the Mara between late July and September. As the migration proceeds northward, the gnus must cross several

DIK-DIK
500mm F4 lens, 1/250 sec. at f/4, Kodachrome 64.

Dik-diks are small, so you'll need to be fairly close up for a large image size. For a more effective perspective, I usually shoot from my vehicle window for the flatter angle it provides.

lakes and rivers, with perhaps the Mara River crossing being the most accessible for photography.

Photographing a crossing involves a great deal of luck. On the Mara River, you're most likely to see a crossing during August and September. At the river, gnus can wait for hours before something triggers a start and one, or more, plunges in. The herd may then follow in one frantic push lasting a few minutes, or in a more orderly line that can take half an hour or longer. There's no discernible pattern to these crossings; I've seen herds cross the river and, less than an hour later, turn around and swim right back, over the same crocodiles, the same high waters, the same slick banks—it made no difference. Gnus are hard to figure.

Gnus are about 1/2 stop under middle tone, although some are even blacker-looking. Meter a middle-tone area, such as the river bank, or meter the gnu directly and underexpose by about 1/2 f-stop.

GNU RIVER-CROSSING
300mm F2.8 lens, 1/250 sec. at f/5.6, Kodachrome 64.

Gnus take all the time in the world to get where they're going, especially if it involves fording a crocodile-infested river. Be prepared to wait.

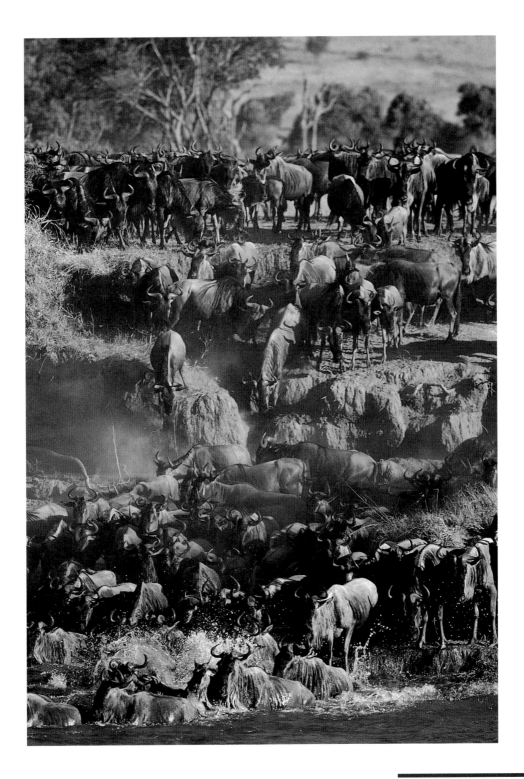

Waterbuck

There are two types of waterbucks, the DeFassa, with a white tail, and the common, with a ringed, white rump resembling a bull's eye. You can often find these large antelopes grazing out in the open, but they aren't very animated. Look for flehmen, when a buck testing a female's urine for estrous curls his upper lip back in a strange smile, and for play fights between males.

The color and tonality of the two waterbucks differ. The common waterbuck is roughly a slate gray color, and a slight underexposure (1/2 to 2/3 stop) of a reading off the animal's flank will work. The more prevalent DeFassa waterbuck is darker and requires 1 to 1⅓ stops less light to make a good exposure. I generally meter a middle-tone area, either vegetation or bare earth, and go with that reading.

DeFassa Waterbuck
500mm F4 lens, 1/500 sec. at f/5.6, Fujichrome 100.

I took this portrait—my favorite of a waterbuck—on my last safari.

Grant's Gazelle

This herbivore is one of the most common species of antelope found in East Africa. It occurs in fair numbers in most of the savannah, grassland, and semiarid parks. Grant's gazelles vary in pattern, but most are generally paler and larger than the Thompson's gazelles, which they resemble. Both varieties have white rumps, although this coloring extends over the tail in the Grant's.

Perhaps because of their abundance, many photographers overlook Grant's gazelles, unless one happens to be in the jaws of a cheetah or leopard. But, you should watch for fights between young rival males or harem bucks and intruders, and for mother-and-young interaction. They're typically lighter than middle tone in value. For best exposures, either meter directly off the animal and open up by 1/2 stop, or meter a middle-tone area in the same light.

Impala

If any species meets a photographer's expectation of an African antelope, it's the impala. About the size of a whitetail deer, the impala epitomizes lithe gracefulness.

Common in many parks, the impala is especially animated for an antelope. Seeing a herd in full flight, bounding in elegant arcs that can span 30 feet, is unforgettable. Males often guard huge harems of does and fawns, and expend a fair amount of energy rounding up strays and driving off any intruding bucks. Mock fights between young males occur more often than with any other species. Groups of impalas make great herd shots, especially when adults and young bunch tightly together facing in one direction. Impalas are also wonderful subjects for another reason—their smooth, brown coats are ideal middle tones.

Thompson's Gazelle

In some areas, Thompson's gazelles are the most abundant antelopes of the grasslands. Characterized by a wagging tail that never seems to stop, Tommies, as they are also called, are abundant on the short grass pastures of both the Masai Mara and the Serengeti.

GRANT'S GAZELLE
500mm F4 lens, 1/500 sec.
at f/6.3, Fujichrome 100.

I used the narrow angle of
view of my 500mm lens to
eliminate any potential
background distractions in
this composition.

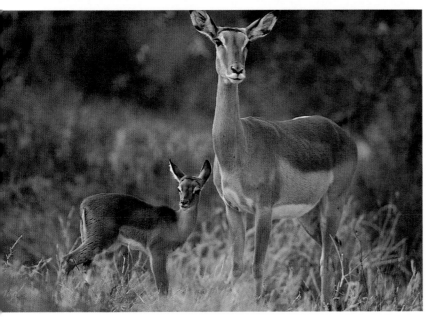

IMPALA MOTHER AND BABY
500mm F4 lens, 1/250 sec. at f/5.6,
Kodachrome 64.

Soft backlighting and two
cooperative subjects combined
here to make an appealing
family portrait.

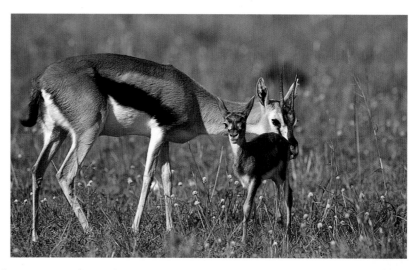

THOMPSON'S GAZELLE
AND BABY
*500mm F4 lens, 1/250 sec.
at f/8, Fujichrome 100.*

*"Tommies" are jokingly
called the fast food of the
plains. They're hunted
by every predator wily
enough to catch this fleet-
footed animal.*

The smallest of the trio of common antelopes, they are, unquestionably, the most frustrating to photograph. Despite their abundance and their nonchalance at passing vehicles, they almost always move off whenever you stop; they'll really wear you down.

Tommies exhibit the same behaviors as impalas and Grant's gazelles. Since they live on the short grass plains, their young are more visible, and in season, it is quite easy to film a young fawn lying in a protective pose. If you should spot a tiny fawn, take your shots from one position and move on. If you frighten the fawn, its movement might attract a predator, and they're easy prey for cheetahs, jackals, and even tawny eagles.

The back of a Thompson's gazelle is a good middle-tone value. If you want a tight portrait, be prepared to stop every time you have the chance. Perseverance will eventually pay off.

Gerenuk

Its Swahili name, *swala twiga* (antelope giraffe), aptly describes this slender, graceful species. An inhabitant of semiarid areas, the gerenuk is easy to find and film in Kenya's Samburu National Reserve and Meru National Park.

Except for its long, slender neck, a gerenuk resembles an impala, and you might mistake it for one from a distance. In fact, in Samburu the two often feed to-

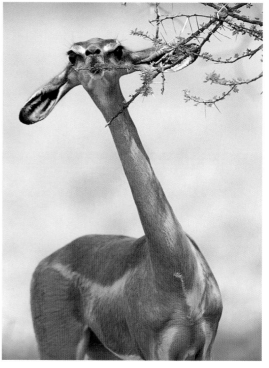

GERENUK
600mm F4 lens, 1/500 sec. at f/5.6, Fujichrome 100.

Don't be surprised if you find the hoofed animals difficult to film. Many are shy and will walk off as soon as your vehicle stops.

gether. Gerenuks differ from all other East African antelopes, however, in their manner of feeding. To browse on the leaves of acacias or other small trees and shrubs, gerenuks often stand upright, resting one or both forelimbs on a branch. This habit makes the definitive gerenuk image, and given three days in Samburu, you're quite likely to capture it.

A gerenuk's face vaguely resembles a camel. Up close, their large eyes and odd snouts remind me of Yoda, the character from the movies in the *Star Wars* trilogy. Cute and photogenic, gerenuks are a middle-tone brown on their backs and a lighter brown on their sides and bellies. A spot-meter reading off the back will yield a correct exposure.

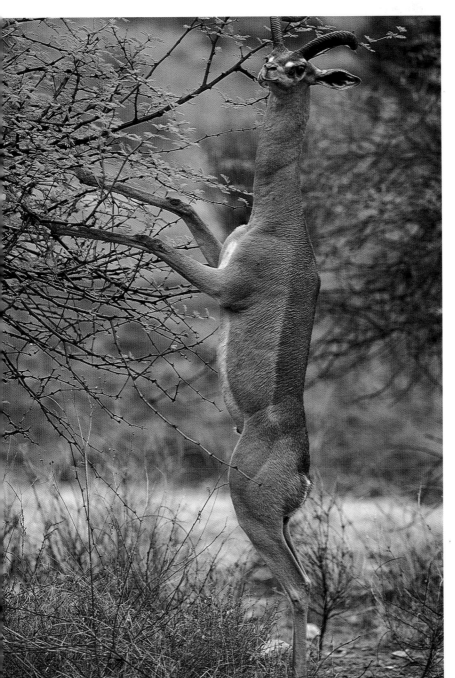

STANDING GERENUK BUCK
600mm F4 lens, 1/250 sec. at f/5.6, Fujichrome 100.

Cloudy yet bright days are perfect for photographing gerenuks since they often stay around brush or low trees, where contrasty light could cause problematic shadows.

Eland

Elands are Africa's largest antelope, similar to an American elk in body size. They wander grasslands and light-brush country, often traveling in small herds of up to 40 adults. In many areas, they are shy, so if you encounter them, plan on making some "record shots" from a distance before attempting to move closer—you might not get another chance. They're especially common and approachable in Nairobi National Park, and I've had my best luck there.

Elands don't do much that you'll want to photograph, with one exception. They are great jumpers, and when they run, they often make a number of prodigious, impalalike leaps that result in striking images. Elands are middle tone, or 1/3 stop brighter than middle tone, in value. To stop or freeze the motion of a leaping eland, use a shutter speed of at least 1/250 sec. If you're up close, use an even faster speed, or pan with the animal to avoid a blurry image.

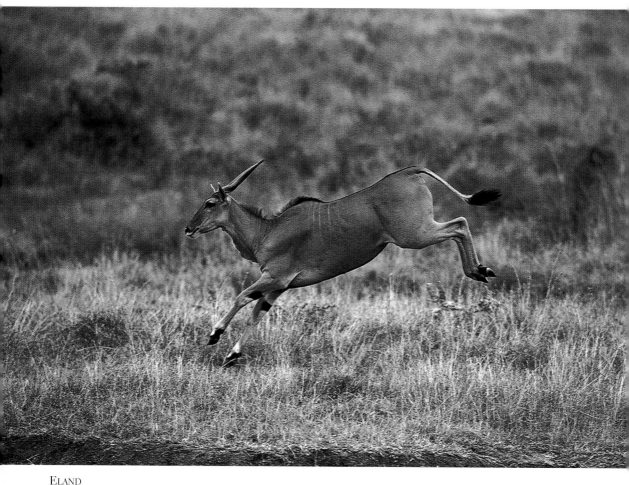

ELAND
300mm F2.8 lens, 1/500 sec. at f/2.8, Kodachrome 64.

Elands are superb jumpers. Be ready, and use a fast shutter speed.

Oryx

Two varieties of oryxes, the Beisa and the fringe-eared, inhabit the semiarid regions of East Africa, and another subspecies, the gemsbok, lives in the deserts of southern Africa. From a distance they have a vaguely horselike shape, which is highlighted when a group gallops across a dusty plain.

Oryxes are especially common in Samburu-Buffalo Springs, where I've often seen herds of over 50 adults. They aren't shy, but you should still take the first opportunity you have for close-ups. I've made trips on which every oryx wandered off whenever a vehicle drew near.

Handsomely patterned and adorned with sword-like horns, oryxes are especially photogenic. Groups bunched tightly together make striking subjects, and close-ups of their long spiraling horns can create interesting abstract images. Oryxes can be animated, too. Play fights between rival bulls are fairly common, and in large herds there are usually a few young calves that gambol about or nurse. Oryxes are lighter than a middle tone; I suggest metering the oryx and opening up 1/3 to 1/2 stop if you're reading directly off the light coat of an adult. The fawn-colored young are close to a middle tone.

BEISA ORYXES
300mm F2.8 lens, 1/250 sec. at f/5.6, Kodachrome 64.

Most fights are little more than contests of strength to establish a dominance hierarchy. They don't last long, so I suggest using whatever lens is handy, if you hope to capture the action.

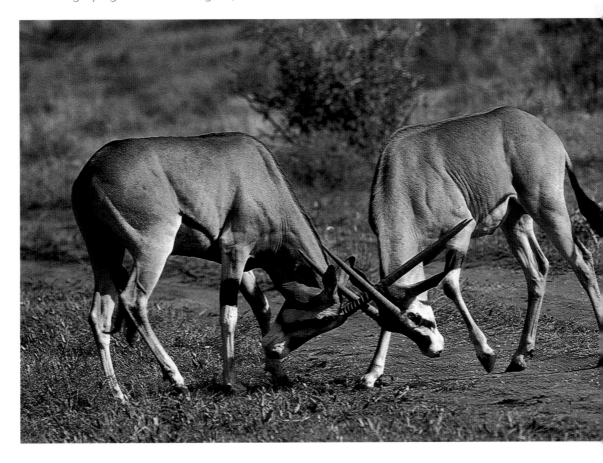

Topi

These animals spend a lot of time standing on small hills and termite mounds watching for predators. Somewhat migratory and occasionally found in herds of 50 or so, topis are most likely to appear alone or in small groups of anywhere from four to eight members.

In the short grasslands that they favor it is easy to spot topi babies, and occasionally, a mother and fawn will cooperate for a close-up. During breeding, adult males put on short, spectacular fights where both combatants drop to their knees and butt heads. Between clashes, one or both topis may stand up and back off, so be careful not to get too close (unless you're using a zoom lens and can zoom out), otherwise one of the two will probably step partly or completely out of your frame.

Topis are about 2/3 stop darker than a middle-tone value. I either meter the animal's side and close down 1/2 stop, or meter a middle tone and leave the exposure alone. Fawns are tawny, and you can meter them directly. For a topi standing on a termite mound framed against the sky, take a reading from a middle-tone area or the blue sky if the sun is to your back and the sky is clear. If the sun is behind the topi, go for a dramatic silhouette, especially if there are clouds in the picture. Meter the whitest areas in the clouds and overexpose by 1½ stops.

Topi on termite mound
500mm F4 lens, 1/60 sec. at f/22, Fujichrome 100.

I needed maximum depth of field to give shape and clarity to the dramatic clouds behind this topi. This requires a slow shutter speed, and I worried that my image wouldn't be sharp, but luckily, it was.

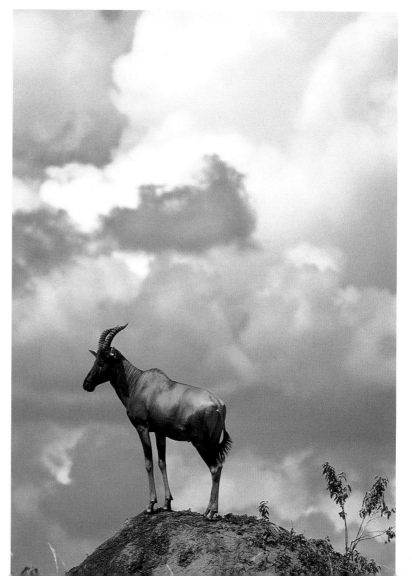

Warthog

Ironically, it is probably the very unattractive, unusual appearance of the warthog that makes it such an appealing subject. With large canine tusks projecting sideways from its jaws and bony protuberances jutting from its skull, the warthog is *bona fide* ugly. And its habits aren't especially attractive either.

Warthogs live in burrows and like to wallow. When disturbed, these high-strung herbivores take off in a fast trot, their long thin tails sticking straight up. They are opportunistic feeders; despite their preference for vegetation, warthogs will feed on fresh carrion. They must kneel to feed on short grasses because the length of their forelegs exceeds that of their necks, and they'll move about in this position as they graze.

You can find warthogs virtually everywhere, but the best location is perhaps Lake Nakuru National Park. They are abundant there and rather tame, especially at the park entrances, where they graze on the lawn. Depending on whether they've wallowed in dark-colored mud or not, warthogs are basically a middle tone or about 1/3 darker.

African Buffalo

The African, or Cape, buffalo is perhaps the most overlooked and least sought-after of the "big five": elephants, rhinoceroses, buffaloes, lions, and leopards. The buffalo, by virtue of its large size and irascibility, was once highly prized as a hunter's trophy. Of the five, the buffalo is probably the most dangerous, especially for the imprudent tourist who leaves

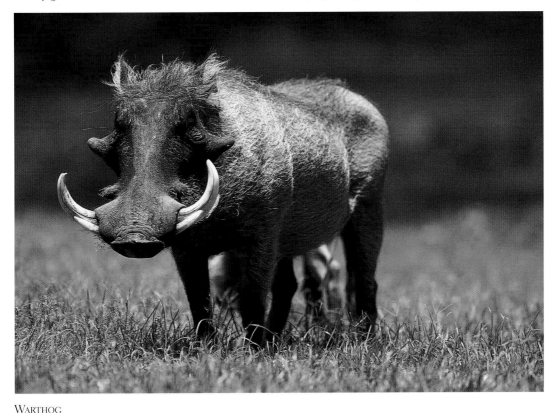

WARTHOG
500mm F4 lens, 1/250 sec. at f/5.6, Kodachrome 64.

Warthogs are common and tame at the Lake Nakuru park entrance.

a vehicle to wander into the brush or thickets. In general, you should always give buffaloes plenty of room; they can be extremely aggressive.

Other than this, however, buffaloes aren't very animated. Unlike other hoofed animals, they rarely spar. My most interesting images are of oxpeckers swarming around a buffalo's snout or ears, or tight close-ups in which I tried to convey their implacable menace. Buffaloes frequent wet areas, and you can get striking images of them rolling in, or caked with, mud.

Not a middle tone unless covered with dried mud, most buffaloes are nearly black, and direct meter readings off them will result in overexposed photographs (because the camera will compensate for the dark mass in its viewfinder). To make a correct reading, you have two options. If you're close enough, take a spot-meter reading off the boss, the thick area where the two horns meet. Or, meter a middle-tone area in the same light and overexpose by either 1/2 or 1 stop to bring out the details that get lost in the black coat. Generally, I overexpose by 1/2 stop if the buffalo fills half or two-thirds of the frame; if it fills the entire frame, I'll overexpose 1 stop off a middle-tone reading—not off the buffalo!

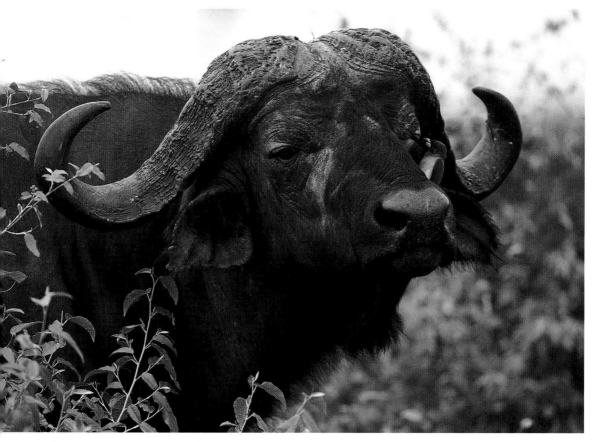

AFRICAN BUFFALO WITH YELLOW-BILLED OXPECKERS
500mm F4 lens, 1/125 sec. at f/4, Kodachrome 64.

Game animals are remarkably tolerant of the oxpeckers that clamber over their faces and into their noses and ears looking for ticks and flies.

The Giants

Giraffes, hippopotamuses, elephants, and rhinoceroses hold a special fascination for us. You're quite likely to stand in awe, jaw agape, and smile, or cry, when you first see these impossibly huge creatures pass gracefully by.

Although elephants and rhinoceroses belong to the big five, we now know these animals as gentle giants, provided we leave them alone. Unfortunately, the world is growing ever smaller for all the giants, and elephants and rhinos are in danger of extinction. Inside the national parks and reserves, however, there are few signs of the bleak future looming ahead for some of these great creatures. Elephants, hippos, and giraffes are surprisingly common in some parks, and in a few parks and at many private refuges, you're quite likely to find both white and black rhinos.

Because of their large sizes, you'll usually need long telephoto lenses to make full-body portraits at the working distances you can expect to have. I've probably used 80–200mm or 75–300mm zoom lenses more often with these subjects than with any other animal. Of course, tight portraits of giraffe's heads, baby elephants, or fighting hippos require longer lenses, and I often use a 500mm lens for these images.

Giraffe

Ironically, one of Africa's most conspicuous and distinctive large mammals can be quite challenging to photograph. Typical giraffe images frequently end up with a distracting horizon line running straight through the animal's neck. Because of their height, you often can't avoid this, but in some locales, dis-

RETICULATED GIRAFFE FEEDING
300mm F2.8 lens, 1/125 sec. at f/4–5.6, Fuji Velvia 50 at ISO 40.

Backlighting and sidelighting can be extremely effective, although a bit trickier to expose. I took a spot-meter reading off the bright grasses below the termite mound and went with that exposure.

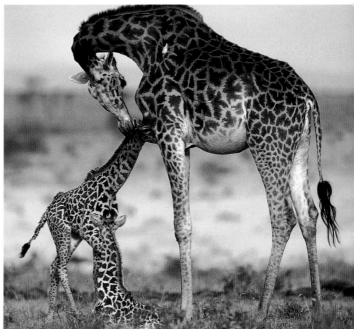

RETICULATED GIRAFFE
600mm F4 lens, 1/250 sec. at f/8, Fuji Velvia 50.

The face of a giraffe is a good middle tone to meter for a proper exposure.

MASAI GIRAFFE AND BABY
300mm F2.8 lens, 1/125 sec. at f/4, Kodachrome 64.

Although I would have been too close to get both giraffes in my frame had the mother kept her head high, I gambled that she would eventually bend over to lick her baby. Luckily, she did.

tant background hillsides or walls of high vegetation eliminate this problem. Another solution is to take photographs either from a downward angle (in relation to the giraffe) by standing on a nearby hill, or from an upward angle by framing the animal against the sky from a low vantage point.

Although your initial impression of a giraffe might be that it is just a tall animal standing against the sky, giraffes offer several interesting shots. Up close, their feeding behavior is fascinating, especially when you can see their tongues stripping leaves from tree branches. Drinking, which the giraffe accomplishes by stretching downward, spread-eagle, offers an infrequently seen, but very dynamic, pose. Scenes of mothers and young, especially ones in which you can juxtaposition the scale of the adult with that if the baby, are also engaging. Two giraffes

together make a beautiful combination, especially if they form a two-headed silhouette shape.

Males often challenge one another, seriously or in play, in fights of varying intensity. Standing side-by-side, males swing their massive necks, battering their rival's side or chest with their huge, bony heads. Most of the time no damage occurs, but giraffes can lift or knock one another off their feet with a well-placed hit.

Three giraffe subspecies, Masai, reticulated, and Rothschild's, live in the area. Their ranges differ, but their basic behaviors are quite similar. There is also a lot of variation in their color: some are a perfect middle tone, while others, particularly older males, are quite dark. It might be best to meter a middle-tone area and use that reading. Generally, however, the faces of most giraffes are a middle tone.

Hippopotamus

The benign, lazy appearance of the hippo belies its nature. Except for the crocodile, the hippopotamus is probably the most dangerous animal in Africa. Separated from a water retreat, or encountered along a river course, hippos might attack, and can do so with surprising swiftness. With their huge canines, humorously called tushes, they can shred a hapless victim in two. They live in herds with one dominant bull tending a bunch of cows.

You'll find hippos throughout East Africa wherever there is water and a suitable grazing area nearby. They don't eat underwater but, instead, graze (generally at night) as far as a few miles from their daylight retreats. Despite their bulk, hippopotamuses are surprisingly active in the water. Dominant males gape threateningly to reinforce territorial boundaries; subadults yawn, play-fight, or porpoise (similar to breaching), lunging a surprising distance out of the water as they do. The yawn is probably the most exciting shot you can expect, and it is easy to catch.

For the most part, hippos are very dark-toned animals, and direct meter readings off wet hippos will yield overexposures. Either meter on the hippo and close down 1 stop, or if there's an area of dry skin that appears gray, meter this and close down by 1/3 stop. The pink skin around the eyes is a perfect middle tone, if you're close enough to spot-meter that area.

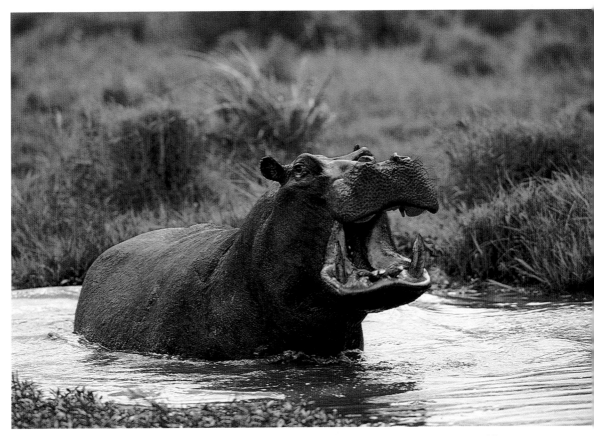

ANGRY HIPPOPOTAMUS
300mm F2.8 lens, 1/125 sec. at f/4, Kodachrome 64.

This hippo, wading in a temporary pool far from its usual haunts, resented our presence and made several false charges before we left.

HIPPOPOTAMUS
POD
*300mm F2.8 lens, 1/60
sec. at f/11–16,
Kodachrome 64.*

*I needed plenty of
depth of field so
that all the hippos
in this pod would
be reasonably
sharp.*

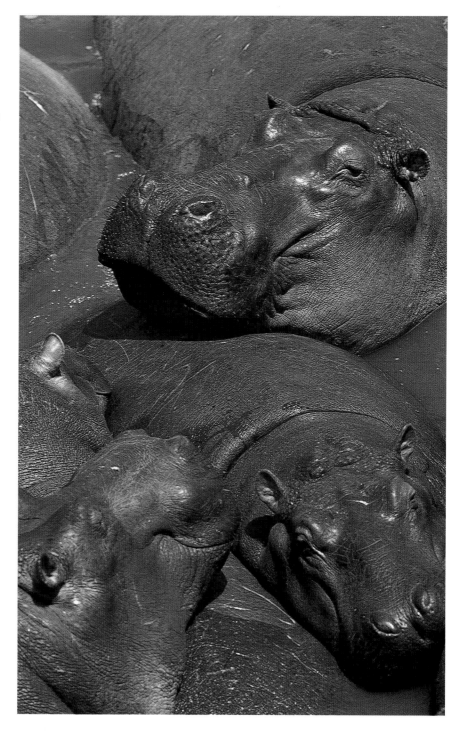

Rhinoceros

Africa has two species of rhinoceros, black and white, and both inhabit East Africa. Their names are misnomers because both types are a dark, slate-gray color. White rhinos get their name from the Afrikaan word for "wide," referring to their broad, grass-plucking mouths. Black rhinos, in contrast, browse using a flexible, triangular-shaped, prehensile lip, which they use to pluck vegetation from low-lying brush. Black rhinos occur naturally in Kenya and Tanzania, but white rhinos, extirpated from much of their former range, are introductions from southern Africa. You're most apt to see them in heavily guarded parks, where poaching is unlikely. The fate of the rhinoceros, especially that of the black rhino, is very uncertain.

In 1985, 60 black rhinos lived within Kenya's Amboseli National Park. As I write this, there are fewer than five there, and probably fewer than 100 in all the game parks of Kenya. This same reduction in numbers has occurred throughout the rhino's entire range, marking one of the saddest conservation tragedies of this century. Obtaining even one photograph of a black rhino is an accomplishment, although it's not too difficult to do in Nairobi National Park (to which they've been translocated) or the Ngorongoro Crater (where there's still a healthy native population). White rhinos have been introduced into Kenya at a few private game ranches and Lake Nakuru National Park, where they are quite easy to photograph.

Huge and prehistoric-looking, rhinos don't have to do much to be interesting. Still, there are several behaviors that you can watch for. Adults mark territory by defecating in the same spot, forming large dung piles that they then disperse by kicking sharply with their hind legs. They also mark territory by urinating on brush. Adults may flehmen. I've seen mating once, which can last as much as one hour and appears comical, with the male balanced upright above his mate. Rhinoceroses rarely fight, but on a recent trip we saw one riding the horn of another when it turned to run. Ouch!

Rhinos are darker than middle tone in value. Either meter directly and underexpose by 1/2 to 1 stop, or meter a nearby middle-tone area. Some parts of the rhino, especially toward the top of the back, can be almost a middle-tone gray in color, but I'd still close down 1/3 stop to avoid overexposure.

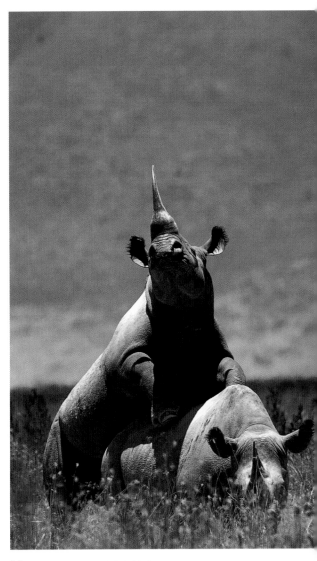

MATING BLACK RHINOCEROSES
500mm F4 lens and 1.4x teleconverter, 1/250 sec. at f/5.6, Kodachrome 64.

The Ngorongoro Crater supports the largest population of black rhinos in East Africa.

Hyrax

Although it doesn't seem possible, this round, squat little animal, which superficially resembles an American woodchuck or marmot, is closely related to elephants. The relationship is an ancient one, and it is the reason I grouped this odd little animal with the giants.

There are three species, although two are known generally as rock hyraxes. The third, the tree hyrax, is nocturnal and is more often heard than seen. Rock hyraxes are widespread throughout East Africa and fairly common wherever there are rock outcroppings, ledges, kopjes, or similar habitats. Even in grassland areas, you'll find hyraxes if there's a suitable outcrop or gorge available. Hyraxes are easy to film as they rest on rocks or along horizontal cliff ledges, and they allow a fairly close approach by vehicle. From a distance, it is easy to mistake a row of hyraxes perched on a ledge for a collection of rocks.

Hyraxes don't do very much except sit, groom one another, or nurse their young. In most locales they're a middle gray color, so metering is easy, although some darker individuals might necessitate metering nearby rocks for your exposure. I'd caution you about using a matrix or multisegmented metering mode, since the deeply shadowed rock crevices that they frequent can bias your reading and cause your camera to overexpose the subject. Although you can find hyraxes in almost every park with suitable habitat, they seem to be particularly abundant and easy to work with at Kenya's Hell's Gate National Park. You are allowed out of your vehicle here, so it is very easy to photograph them with a 80–200mm zoom, or smaller, lens. I've made some interesting shots with a 35mm wide-angle lens and fill flash.

ROCK HYRAX
300mm F2.8 lens, 1/60 sec. at f/8, Kodachrome 64.

In this picture, your eye goes to the pale lichen first, before being surprised and rewarded in finding the cryptically colored hyrax.

MARY ANN WITH A ROCK HYRAX

Although I've filmed hyraxes throughout East Africa, I think the hyraxes at Hell's Gate National Park in Kenya are the tamest and most cooperative.

Elephant

Animated, huge, and expressive, elephants are simply spectacular. You can find them in most national parks wherever there is water, grasses, and mixed woodland. They often travel in herds, which are led by an old female and composed of several elder females, their daughters, and their daughters' young.

Elephants are normally fairly docile, but because of their large size and somewhat unpredictable nature you should treat them with the utmost respect. In some parks, such as Kenya's Amboseli, they are so accustomed to vehicles that you can come within only a few meters of a grazing elephant and be reasonably safe. In other areas, that close an approach could trigger a charge. Elephants generally signal aggressive intentions by raising their trunks, flapping their ears forward, and occasionally trumpeting or growling loudly. Don't take elephants lightly; they can be extremely dangerous.

Elephants usually visit water around midday. If you know their route, or see which direction they're going, drive ahead and be ready as they approach. In water, elephants appear to actually play, rolling, flopping on their sides, and spraying themselves and one another with water using their trunks. They browse, stripping branches and leaves from trees, some of which they knock flat for better access. They also pluck grasses or tiny saplings by daintily wrapping their trunks around the plants, then kicking them free from the ground with a foreleg.

These giants often explore one another with their trunks, even placing them into each other's mouths. They also test one another's strength by butting heads, wrapping trunks, and shoving. Fights between bulls are rare, but they're breathtaking in their intensity. Calves are irresistible, especially when they're exploring away from their mothers, playing with other young elephants, or learning to use their

AFRICAN ELEPHANTS UNDER A TREE
80–200mm F2.8 lens, 1/125 sec. at f/11, Fujichrome 100.

By high noon on sunny days, most animals seek shade.

trunks. The young are especially comical around water. They seem to enjoy life.

The elephant's slate-gray color is slightly darker than middle tone by about 1/2 stop, although there is often a lighter area on the upper sides or back that you can use as a metering area. Depending on the soil type at the park you're in, however, elephants can be almost any color, from gray-white to deep red or even black (when they coat themselves with sand, mud, or wet clay). Choosing the right exposure, then, will depend on your own evaluation of the tonality. When in doubt, meter a middle-tone area.

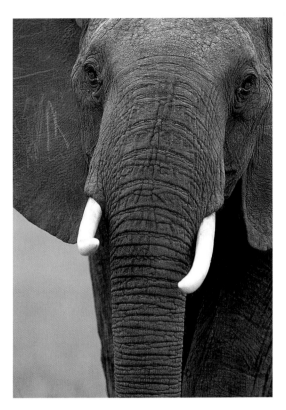

ELEPHANT
500mm F4 lens, 1/250 sec. at f/5.6, Fujichrome 100.

Getting a good image size is rarely a problem with elephants, although extreme close-ups still require a fairly close working distance.

AFRICAN ELEPHANTS WITH TRUNKS ENTWINED
300mm F2.8 lens, 1/250 sec. at f/5.6, Fujichrome 100.

Fights between elephants are rare. Young males will sometimes test each other, however, by wrestling with their trunks and butting heads.

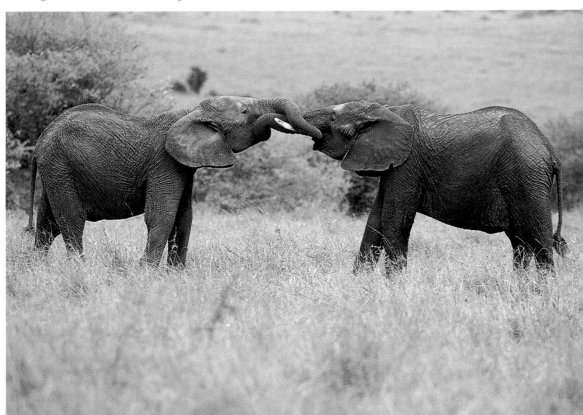

Birds

With countless waterfowl, scavengers, raptors, and perching birds, East Africa's diverse and colorful birdlife is a photographic gold mine. In parks and at the tourist lodges, you can always expect to encounter a few species that are remarkably tame and will afford tremendous shooting opportunities that will complete your safari coverage.

For example, in Lake Nakuru, one of the smallest national parks, there are over 400 recorded bird species, ranging from pelicans to weavers to sunbirds. Sadly, photographers tend to concentrate only on the largest or most spectacular species, such as flamingos or vultures, and ignore the myriad smaller birds that make wonderful subjects in their own right.

As a rule, successful bird photography requires longer lenses than mammal photography. While some birds are large, such as a five-foot-tall marabou stork or a nine-foot ostrich, most are chicken-sized or smaller. A 300mm lens with a 1.4x teleconverter will be adequate for many subjects, but for the smaller songbirds, you'll have better luck with a 500mm or 600mm lens. I wouldn't suggest using a larger lens unless you have a vehicle to yourself. Image shake at high magnifications is significant, and even the smallest movement inside a vehicle could ruin your shot. Besides, you might find yourself at odds with others, since you wouldn't need to be as close to a subject as those with shorter lenses. A better solution is to add a 1.4x teleconverter to a more manageable long lens for the rare times that you need extreme magnification.

Unlike the mammals, where each species has unique behaviors, bird activity is a little more generic. As such, it is fairly easy to lump similar species together in discussing shooting strategies.

Vultures

Soaring lazily overhead, squabbling around a kill, or sitting patiently in a twisted dead snag, vultures are a highly visible feature of the East-African savannah. You're likely to see several species, from the condor-like Nubian, or lappet-faced, to the turkey-sized

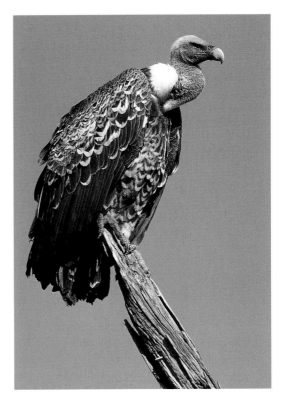

RUPPELL'S VULTURE
500mm F4 lens, 1/250 sec. at f/8, Kodachrome 64.

Portraits of vultures can be surprisingly attractive.

hooded and Egyptian vultures. Contrary to popular belief, vultures rarely circle above dying animals waiting for them to expire. True, vultures do circle in groups, but generally, they do so to catch air thermals or updrafts that will propel them skyward.

When they spot a kill or see an available carcass, however, vultures waste no time; they fly straight to it, a habit used by canny safari guides for finding lions and hyenas. A string of vultures rarely flies in a direct path unless there's a reason, and that's usually a kill. If a predator still occupies the kill, the vultures gather on a perch or the ground nearby; once the predator leaves, they fly to the site or proceed on foot, single file, in a comical line that makes for an interesting shot.

RUPPELL'S VULTURE AT GNU CARCASS
500mm F4 lens, 1/250 sec. at f/4–5.6, Kodachrome 64.

With their long necks, vultures can reach scraps of meat deep within a carcass body cavity, while keeping their bodies relatively clean.

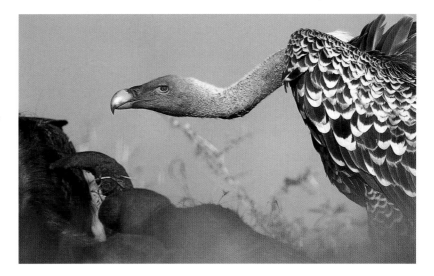

Ideally, it is best to arrive at a kill before the vultures take claim. In this way, you might see the vultures flying in, which is an excellent opportunity to record some in-flight shots. Whenever possible, vultures land facing into the wind, so try to position yourself with the birds flying toward you; in some grassland parks where there are plenty of dirt tracks to use, this is easy to do, but in others, you might be out of luck.

For in-coming shots, you have three options. If you're using an autofocus lens and a camera with predictive, or track focusing, you can simply keep the bird within the focusing brackets and fire as it approaches. If you're using a manual focus lens, you can manually follow focus, or you can prefocus at a set distance, and snap the shutter at the instant just prior to when the bird appears sharply in focus. If you wait until the image is sharp, the bird will have passed that point by the time the shutter opens.

Activity on a kill can be frenetic. Vultures swarm and squabble, hissing and cackling, and pecking and wrestling as they contest choice spots, sometimes jumping on top of each other in a squirming, feathery pyramid. In these fast-paced moments you have two options: use either a fast shutter speed to stop the action, or a very slow one to convey the chaos with blurriness. Vultures can be fairly tolerant of vehicles. Still, it is best to take a few insurance shots as you ap-

proach, in case the birds flush. Vultures vary in tonality. Egyptian and palmnut vultures are almost white, while hooded and Nubian vultures are quite dark. The Ruppell's and white-backed varieties lie between these extremes.

Birds of Prey

Hawks and eagles are common in East Africa, and some species are incredibly tolerant of vehicles. Ironically, many tourists from the northern hemisphere have better photographs of African birds of prey than they do of species in their own country. That's certainly true for me. For all my time with bald eagles in Alaska and Florida, I've never had the chance to make frame-filling shots by simply driving up close to birds as I've done while on safari.

Still, raptors, as birds of prey are collectively known, can be spooky and quick to take flight, so you'll have better chances with longer lenses. Raptors are fairly conspicuous, often perching on dead snags or open, unobstructed limbs where there's plenty of visibility. Some scavenge, and you can find them around the edges of vulture kills waiting for a chance to steal a tidbit. Some African eagles are powerful predators in their own right, and are capable of killing small antelopes that are too heavy to carry off. With a slow approach, you might be able to creep in for close-up images of a bird on a kill.

GRAY KESTREL
*600mm F4 lens, 1/500 sec.
at f/5.6, Fujichrome 100.*

*The gray kestrel is one of
Kenya's smallest birds of
prey. Most are skittish and
fly off if you approach too
closely.*

**MARTIAL EAGLE ON
GAZELLE KILL**
*300mm F2.8 lens, 1/250 sec.
at f/6.3, Kodachrome 64.*

*After first spotting this eagle,
I approached it slowly, and
after a few minutes it relaxed
and began feeding.*

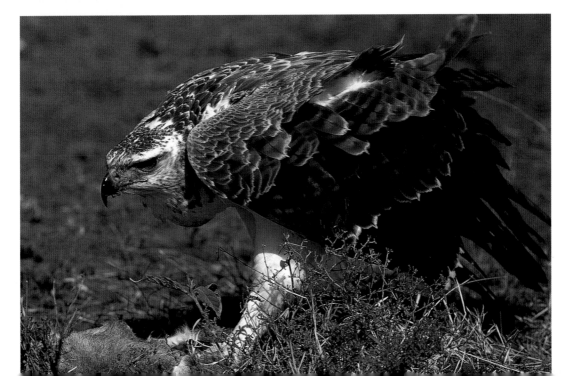

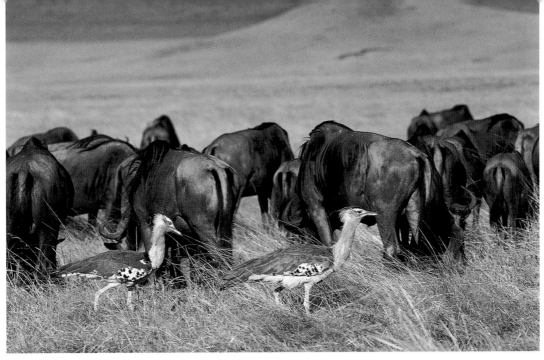

KORI BUSTARDS
300mm F2.8 lens, 1/250 sec. at f/8, Kodachrome 64.

It is often helpful to provide a scale of reference for unfamiliar birds. As this image clearly shows, kori bustards are huge.

SECRETARY BIRDS AT NEST
500mm F4 lens, 1/250 sec. at f/5.6, Kodachrome 200 at ISO 250.

The secretary bird is famous for its habit of hunting snakes, but you're far more likely to see it catch a small rodent, lizard, or large grasshopper. Although they're ground-hunters, secretary birds nest atop flat acacia trees.

Ground-Dwelling Birds

East Africa's vast grasslands are host to a multitude of birds that spend most of their time walking, rather than flying. The most conspicuous of these is, of course, the ostrich, but many smaller birds, including bustards, cranes, storks, spurfowl, plovers, and secretary birds, also provide plenty of shooting opportunities.

Apt to be accustomed to nearby passing vehicles, many ground-dwellers are easy to photograph. Simply drive up close, stop the engine, and shoot. Others make more challenging subjects, especially if they're actively hunting. For these, try driving ahead so that the birds walk into you. It is easier to photograph nervous birds when *they* move toward you, rather than when you try to approach them.

Water Birds

Since most safaris are land based, you won't see water birds up close that frequently. However, there are a few good locations, such as lakes Baringo, Naivasha, and Bogoria (all in Kenya), where boats or game tracks provide good shooting opportunities, and fortunately, even "terrestrial" parks have wetlands that attract great birds. Having wings, birds can of course go anywhere, and given time, they generally do.

At Baringo or Naivasha, where you can take photographs from a boat, it is possible to creep in surprisingly close to some species. Your lens choice may be dictated by your camera steadiness, and whether you can use a tripod or must hand-hold. If you're tripod-mounted, you can use a long lens, such as a 500mm, provided everyone else in the boat remains very still. Obviously, the fewer in the boat, the better. If you're hand-holding, you might be limited to lenses of 300mm or smaller, even if you mount the lens on a shoulder stock (a special lens brace). In either case, use the fastest shutter speed possible.

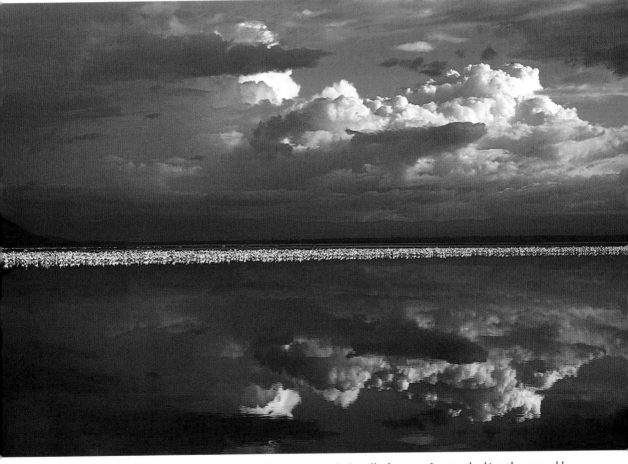

LESSER FLAMINGO REFLECTION
24mm F2.8 lens, 1/125 sec. at f/11, Fuji Velvia 50.

On one particularly still afternoon, I stopped taking the same old close-up, telephoto-lens shots of flamingos and caught this wonderful mirror image with a wide-angle lens instead.

CROWNED CRANES
*500mm F4 lens, 1/125 sec.
at f/5.6, Fujichrome 100.*

*Crowned cranes are common
in most parks that have some
permanent water holes.*

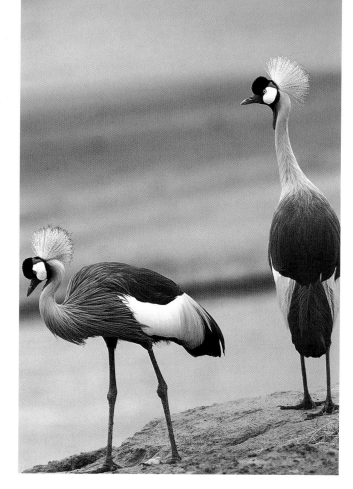

LESSER FLAMINGOS IN FLIGHT
*500mm F4 lens, 1/250 sec. at f/4,
Kodachrome 64.*

*The true beauty of this bird's fiery
plumage is revealed when a flock takes
flight. It is a wonderful sight, but it is
difficult to capture since the birds often
fly far out across the water. I used a
manual focus 500mm lens and panned
with the action.*

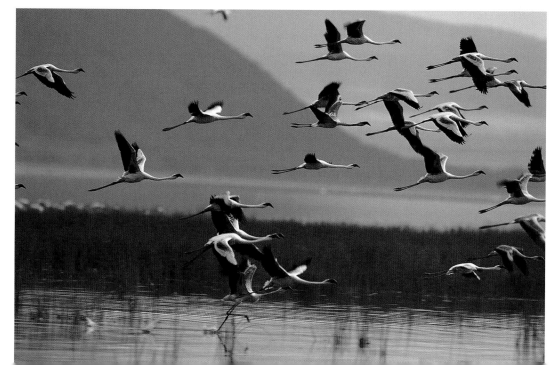

Perching Birds

The vast majority of East African birds are song- or perching birds. Many of these are infrequently sighted, inhabiting forest or brushland. Others, because of their small size, are difficult to identify or appreciate. Still, there are a huge number of birds that are conspicuous enough to make attractive subjects. Perching birds exhibit a wide range of tolerances to vehicles: individuals of any species can be either re- markably tame or extremely skittish. Sometimes it is possible to simply drive up close and shoot, but usually, a conservative approach is more effective.

Generally, I make a series of insurance, or basic record, shots as I slowly drive in closer, stopping every few meters. After this, I drive in slowly, keeping my lens ready and on my beanbag until I'm in position. This method wastes less time and film, and has proved especially useful with small songbirds.

BEE-EATERS
600mm F4 lens, 1/250 sec. at f/4, Fujichrome 100.

Although fairly conspicuous perch feeders, bee-eaters nest in burrows dug into steep banks. You'll have your best luck around these nests, as the birds usually frequent a few favorite perches nearby. I set up a tripod and sat on the grass to keep a low profile. The birds appeared within a few minutes.

LILAC-BREASTED ROLLER
500mm F4 lens, 1/250 sec. at f/6.3, Kodachrome 64.

Rollers are common, widespread, and colorful, and you're likely to find one that's tame enough to make a great portrait. Rollers make a good middle-tone subject, as long as you don't frame them against too bright a sky.

Safari Journal

ANY COLLECTION OF safari photographs generates questions. How many safaris did it take to produce the images? How much film did you use? It is natural to assume that you need several trips to make an outstanding portfolio, but you can certainly make many wonderful images on just one safari. To record my experiences, I keep safari field diaries, noting the game-drive highlights and the shots I hoped would be each day's best. I strongly urge you to do the same. It preserves all your wonderful memories at trip's end, and is helpful when you review your images at home. Here, then, is one of my field diaries. I hope it provides you with a realistic depiction of a typical trip and answers any lingering questions you might have.

THOMPSON'S GAZELLE AND OXPECKERS
500mm F4 lens, 1/250 sec. at f/8, Fujichrome 100.

Working distance was the issue here. At close distances, a telephoto lens' depth of field is virtually nonexistent, so any movement by the subject changes the point of focus. Even at f/8, the depth is too shallow for both the gazelle and the bird to be in sharp focus.

November through December

Although I've booked four other November safaris in the past, the vagaries of Kenya's short rainy season, which runs from late October through December, always worry me. This year, November was the wettest in memory, with the city of Nairobi receiving as much precipitation as would be expected during April's long rains. Too much rain can ruin any safari, making shooting difficult and the roads impassable.

As it turned out, the wet weather had some positive effects for us. Dust—a constant annoyance during the dry season, clogging one's lungs and gear— was almost nonexistent. On our few very dry days, the little dust we did experience seemed doubly intrusive. Areas such as Samburu, where most images are usually studies in dusty browns, were vibrant green and rang with the whistles and songs of weaver finches, whose nesting activities were triggered by the rains.

This is also the time of year when Thompson's gazelles and topis drop their young on the open grasslands. Predators seeking these newborns hunt the open areas, and scavengers, missing the large and bountiful carcasses present during the gnu migration, range widely, even by day, in their search for food. Fireball and pajama-striped lilies sprout in the low growth, and skies of such diversity surround us that my memories of the hot, pale blue canopy of August are dull in comparison. I love November's weather.

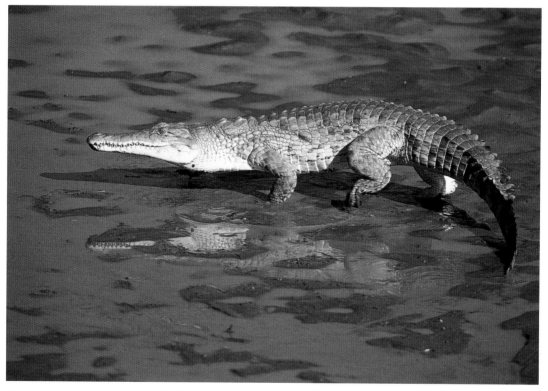

NILE CROCODILE
500mm F4 lens, 1/250 sec. at f/8–11, Fujichrome 100.

You'll frequently see crocodiles lying lazily on river banks and mud flats. If an animal approaches, the crocodile will slip into the water to attempt an ambush as the animal drinks.

Day One: Nairobi to Samburu

It is a six-hour drive to Samburu, covering some of Kenya's most diverse habitats. As usual, we encountered rain in the highlands, but to the north, in the dusty haze, we could see the semiarid landscape of Samburu in full sunlight. That was encouraging.

If an auspicious start bodes well for the success of a trip, then this safari will be stellar. In our first two hours in the park we saw all three big cats, including a lioness doggedly chasing a very frightened cheetah and a leopard that nonchalantly passed in front of Mary Ann's van. Three cats on a single game drive — this was a first for us in Samburu.

Perhaps it is lucky that Mary Ann even arrived in camp at all. En route we passed an angry-looking bull elephant in the final stages of knocking down an acacia tree. Three of our vans pulled up onto the main road for pictures, but Mary's van arrived on a different track, approaching the elephant head-on. As we watched, the elephant flared its ears and charged. The driver whipped the van into gear and retreated, with the elephant just a few yards behind. Luckily, a fallen tree or dead-end road didn't block their retreat. *Photo highlight:* Charging bull elephant.

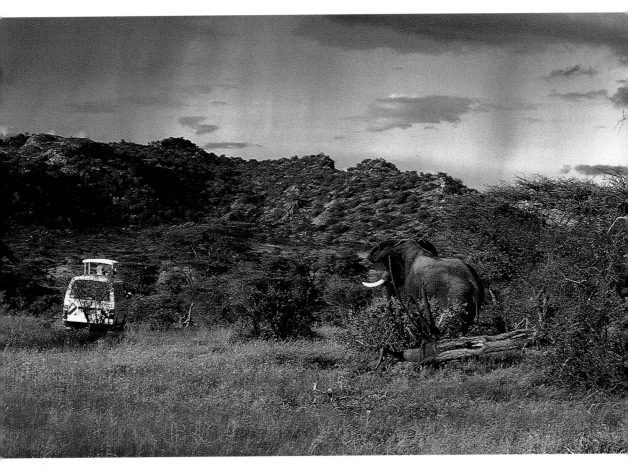

CHARGING ELEPHANT
300mm F2.8 lens, 1/125 sec. at f/8, Fujichrome 100.

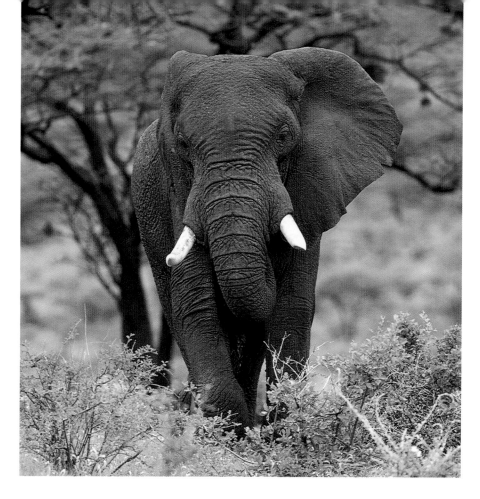

AFRICAN ELEPHANT
300mm F2.8 lens,
1/125 sec. at f/8,
Fujichrome 100.

Because of the dark, clay coating on this "red" elephant, I took a meter reading off the surrounding vegetation to determine my exposure.

Day Two: Samburu

We awoke to rain beating down on our tent thatch in the early A.M. hours, and a hard rain continued to fall throughout the remainder of the night. By sunrise the dry trails that we crossed to reach our camp were flooded five feet deep with runoff. For the first time ever in Samburu, we had to delay our morning game drive to wait for the high water to recede. Fortunately, this usually dry land drains quickly, and by 9:30 A.M. the road was once again passable.

Elephants defined the day. A herd approached quite close to our van, and memories of Mary's earlier elephant encounter kept everyone on edge until we reached a good, safe section of track. One bull attempted to knock over an acacia, and as it pummeled it with short, powerful thrusts of its head, newly built weaverbird nests cascaded down like huge, green snowflakes.

We had several good opportunities to photograph dik-diks throughout the day, a few good sessions with giraffes, and a great one with a herd of Beisa oryxes grazing and digging around a termite mound nearby.

We also had three leopard sightings—an extremely good omen—and saw one sleeping male lion that awoke, stretched languorously, and passed within a few meters of us as he headed toward the river. We followed a short distance behind him, hoping for more shots, and promptly got stuck in the soft clay of the river's flood plain. Luckily, it only took a little push to get us back on track. *Photo highlight:* Elephant herd near our van.

Day Three: Samburu

The day began with the first crystal-clear skies we'd seen since arriving in Kenya nearly three weeks ago. Although a welcome change, the sun brought harsh light and generated steamy, humid conditions that are unusual in this arid land.

One member of our group damaged his 500mm lens when his van hit a bump, and the unsecured lens tumbled to the floor. Luckily, he had a 300mm and a 1.4x teleconverter as a backup, so he was still equipped for the trip.

I missed a great shot of a reticulated giraffe and an oxpecker. I was using my 600mm for an extremely tight portrait. Before I could focus, an oxpecker landed on the giraffe's center horn, but it was gone almost as quickly as it appeared. Even had it stayed, I might have missed it, since I was using Fuji Velvia film, which was probably not fast enough for the shooting conditions.

We also came across a large, tame troop of baboons. One very young baby hopped alongside its mother, then sprang onto her back, riding jockey-style.

We had many shots of impala herds on the afternoon game drive, and our first good look at a lilac-breasted roller. We also encountered another wet-season highlight—a large leopard tortoise—walking down one of the sand tracks close to our usual breakfast picnic spot. Although Mary Ann had seen one on a recent trip, this was my first tortoise sighting in nearly eight years. Using my 35–70mm zoom lens at ground level, I got some interesting perspectives as the reptile lumbered by. *Photo highlight:* Walking leopard tortoise.

LEOPARD TORTOISE
35–70mm F2.8 zoom lens, 1/125 sec. at f/11, Kodachrome 64.

Turtles aren't as slow as you might think. This becomes especially apparent when you're trying to film one.

Day Four: Samburu

The day got off to a slow start with high humidity and an unusual haze that softened the desert's harsh light and obscured distant landscape details in a soft, gray mist.

As the sun rose higher, the tall grass sparkled with dew—unusual for the dry Samburu. For an hour or so, we followed a pair of hunting cheetahs. Birds were everywhere, and the air rang with their chatter. We saw one of the leopards that regularly drags bait from the lodge across the river, and had several good photo opportunities.

We spotted a very young giraffe baby with its mother. The female, a bit nervous, remained motionless and on the watch; finally, some of the other vans left to find something more exciting, and she relaxed. She approached her baby, who began to nurse. We cut our giraffe photography short, however, to see a cheetah feeding on an antelope kill. Unfortunately, the cat was in the shade of a large tree and, therefore, wasn't the best subject for great shots. Still, with two spotted cats on one game drive, our luck seems to be holding. *Photo highlight:* Mother giraffe and calf.

RETICULATED GIRAFFE
300mm F2.8 lens, 1/250 sec. at f/5.6, Kodachrome 200 at ISO 250.

We waited about half an hour for this giraffe to relax and attend to her young baby. I metered the brush near the giraffe's feet for the exposure.

Day Five: To Lake Nakuru

It is a long drive to Lake Nakuru National Park. As they always do, the drivers tried taking a shortcut on a road that's impassable in the kind of wet weather we've been having. But luckily, a marooned truck, which was stuck in a huge quagmire, made them change their minds. It's a difference of twenty miles, but the long route is on a safe, paved highway, and we made the trip without event.

The park's white rhinos can be spectacular; on a trip two weeks ago, we'd encountered 15 rhinos in the short grasses around the lake. Unfortunately, these animals were gone now.

Flamingos flew past, but I soon lost interest. Rather than shooting more flamingos, I concentrated on shoreline details instead. A light breeze had pushed thousands of pinkish white feathers to shore, creating a line of pink debris that slowly crept forward with the help of the wind-generated tide. I shot a few rolls of this often-overlooked detail. *Photo highlight: Floating flamingo feathers drifting toward shore.*

FLAMINGO FEATHERS
24mm F2.8 lens, 1/30 sec. at f/22, Fuji Velvia 50.

To maximize my depth of field when making this image, I used my wide angle lens at the smallest aperture possible.

Day Six: Lake Nakuru

The morning game drive was slow. I practically missed the best shot by almost photographing some buffaloes and their reflections without film! We saw some baboons, warthogs, bushbucks, and waterbucks. Quite out of character, our driver misread two different warthogs, driving too close the first time and gunning the motor in approaching the second. Both times the great hogs ran off before I could fire.

The afternoon game drive was exciting. I spotted another van far down the road flashing its headlights as we crested the hill. (Drivers flash headlights as a signal that great game is about.) Canceling any other plans we had, we raced to the spot to find a fine leopard lounging across the thin limb of a yellow-fever acacia tree.

Leaving that cat, we joked that we'd go find another leopard. Within minutes, we had! While we glassed the long grasses, a troop of baboons started screaming, running downhill toward us. The spotted cat bounded toward a thicket, with the big male baboons in close pursuit. Unfortunately, everything happened much too far away and too quickly to get a good shot. *Photo highlight*: Leopard in tree.

LEOPARD IN TREE
300mm F2.8 lens, 1/250 sec. at f/2.8, Fujichrome 100.

A distracting bright white sky framed this leopard from most camera positions. Driving down the road, I found a spot where distant trees formed a pleasant, uniform background.

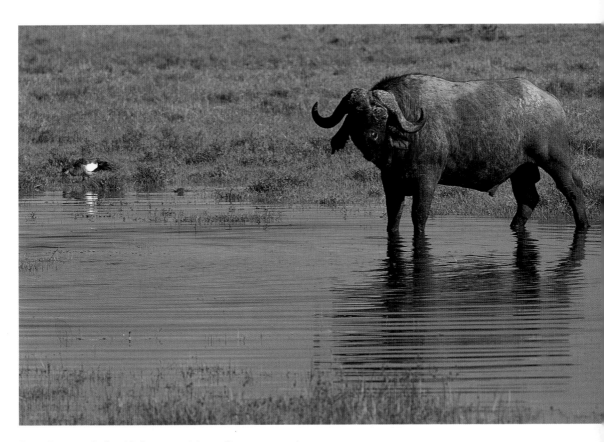

Day Seven: Lake Nakuru to Mara Sarova

We'd just begun our last game drive in Nakuru when our drivers heard of two leopards together. We raced to the spot, but by the time we found them, they had slipped into the thick cover of a fallen tree to mate. Hoping to see two leopards together, we waited for an hour or so, but they never reappeared.

Meanwhile, Mary Ann spotted a lone white rhinoceros in the distance, but it presented only fair shooting. We also saw two of the best male lions we'd ever seen at Nakuru; the pair eventually moved so close to us that we were able to get some good head shots.

While we filmed flocks of African spoonbills, little egrets, and Egyptian geese that had gathered at a roadside pond, a couple of African buffaloes lumbered by. This time I was ready—with film in my camera! *Photo highlight:* Buffaloes and birds.

AFRICAN BUFFALO
300mm F2.8 lens, 1/125 sec. at f/8–11, Fujichrome 100.

Buffaloes are usually much darker than a middle-tone gray, but there are always exceptions. You could trust a direct spot-meter reading off the light rump of this buffalo, which is exactly what I did.

Day Eight: The Lower Masai Mara

Shortly after leaving camp we spotted a pair of courting black rhinos. They weren't shy, wandering through the brush and scent-marking their territory. The most interesting aspect of this encounter was hearing the two rhinos communicate. Occasionally, one or both would give a very unrhinoceroslike cry, sort of a cross between an elk's whistle and a baby alligator's grunt.

Later that morning we saw a fine pair of mating lions. Usually, mating pairs always attract a crowd and create a traffic jam, which can make good shooting impossible. We were lucky on this day because only a few vans appeared. Invariably, it seems that the lions moves right before mating, leaving a perfect position for one from which the shooting angle is poor. This pair was the exception. With their remarkable cooperation, I shot using everything from my 80–200mm zoom lenses, to my 300mm, 420mm, and 600mm telephotos.

The afternoon game drive was a wash out. The rains came early, and after doing some roadside shots of hartebeest and topi, we called it a day. *Photo highlight*: Mating lions.

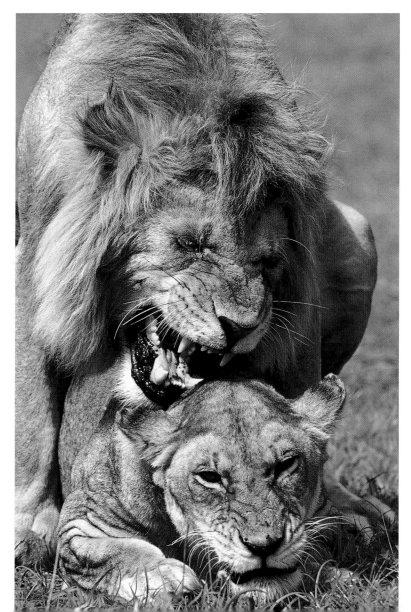

MATING AFRICAN LIONS
500mm F4 lens, 1/250 sec. at f/8, Fujichrome 100.

Typically, at the end of each mating the lioness snarls, turns, and swats her suitor with a heavy punch. This pair was particularly benign, and each bout ended only with a grimace.

Day Nine: The Lower Masai Mara

On the A.M. drive we came across four hunting lionesses. As we watched, a warthog appeared—the lionesses stalked, charged, and missed. Not much later, a pair of gnus loped into view, and the cats began a second stalk. Although one cat tried cutting the gnus off, the antelopes passed by before she got into position. The distance was really too great, however, for any quality photography, so we moved on. We also had some good zebras, Thompson's gazelles, and a cheetah, and felt pretty lucky, since cheetahs are less common in this lion- and hyena-rich environment than in the upper Mara.

The P.M. drive was unproductive until we spotted a trio of lionesses and a small cub far in the distance. They advanced in a straight line toward us and, as we'd hoped, stopped to rest and bump heads. Soon, over 18 vans appeared. Leaving this circuslike atmosphere, we headed for camp. *Photo highlight*: Lionesses and cub.

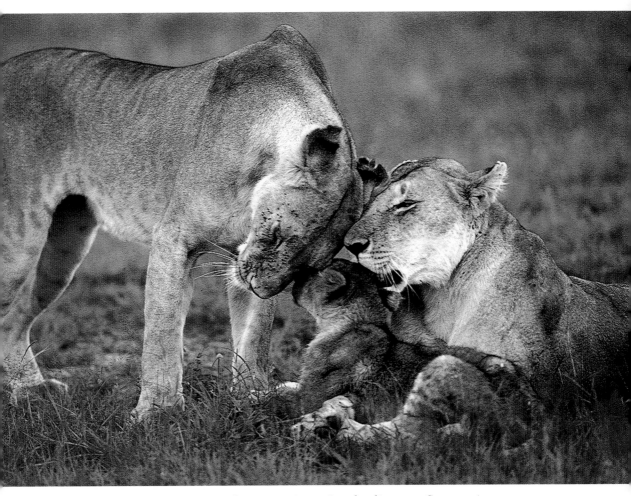

LIONESSES
500mm F4 lens, 1/250 sec. at f/4, Kodachrome 200 at ISO 250.

You can always expect interaction when lions meet. Some greetings can last for several minutes, entailing head butts and grooming, while some involve merely touching muzzles.

Day Ten: Mara Sarova to Mara River Camp, Masai Mara

Today was a very busy day. Shortly after leaving camp we found a secretary bird building a nest. I obtained some great images at several focal lengths from 300mm to 600mm.

We spotted a very cooperative topi mother and baby, and while some new mothers run, a few, such as this one, can be oblivious to vans. The lighting was harsh, and as an experiment, I used TTL flash on a -2 setting for fill flash, hoping it would soften the shadows and add to the shot. A few times the baby nursed and nibbled experimentally on grasses.

Mary Ann spotted a cluster of red-billed oxpeckers on a Thompson's gazelle that was suffering with an injured, bloody ear (see page 122). Intent on the fresh wound, the birds harried the animal mercilessly, pulling at the exposed flesh.

Heading north we spotted a pair of dung beetles rolling a dung ball. They walked backward, rolling the dung ball toward their burrow. Dung beetles lay eggs on dung balls, which newly hatched young use as food. I didn't have a macro lens along, but fortunately, my 35–70mm zoom has macro capability at 35mm. It must have been a comical sight as I inched along on my belly, following the beetles down the road.

In driving from the lower to the upper Mara, we had to pass through two usually dry washes that were now covered headlight-deep with water. Our driver pronounced the route impassable. After a brief discussion, mainly centering on the fact that we'd driven too far and that it was too late to consider an alternative, my driver sped toward the lugga laughing, "We have no choice!" Fortunately, we made it through. *Photo highlight:* Oxpeckers and dung beetles.

DUNG BEETLE
35–70mm F2.8 lens, 1/60 sec. at f/11, Fujichrome 100.

I'd love to have a video of the photographers filming this: sliding forward on their bellies to keep up with a rolling ball of dung! Hey, what did you do on your safari?

Day Eleven: Northern Masai Mara Reserve

In the morning we saw elephants at sunrise, hippopotamuses fighting at the river, a great steppe eagle, and a sleeping leopard.

We started our afternoon drive looking for "Half-Tail," the female leopard who had lost a good portion of her tail from a baboon bite, and her half-grown male cub. Two weeks ago there were two cubs, but a lion killed one. This was a particularly tragic loss, as the young leopard was extremely tolerant of vehicles and, at nearly a year old, was past the most vulnerable prey age. We eventually found Half-Tail resting in a low acacia tree from which she could watch for impalas, but she didn't stay long. After taking some shots, we decided to meander around the immediate area shooting "filler" species that we missed or ignored earlier; we were very productive, filming banded mongooses, gray kestrels, fighting Tommies, and a singing yellow-breasted longclaw. We decided to try one last time to get some better shots of Half-Tail, and we found her in another tree within 100 meters of her previous perch. We filmed her from several positions with 300mm and 420mm lenses. *Photo highlight: Leopard in tree.*

LEOPARD IN TREE
300mm F2.8 lens, 1/125 sec. at f/5.6, Fujichrome 100.

This hunting leopard was backlit by the late afternoon sun, which really highlights his wonderful eyes.

Day Twelve: Northern Masai Mara Reserve

Today was a great lion day, beginning with a large pride of 17 cats in the leopard's lugga. We'd just begun to photograph when a small group of Maasai women walked into view on a distant hilltop. All the cats immediately headed for cover, including two huge male lions who snuck away like a pair of shy coyotes.

Among the short grasses we spotted a Thompson's gazelle baby, still wet from birth. The mother ran off as we approached, so we made some quick shots and left. As soon as we departed, the mother circled and rejoined her fawn.

Nearby, a pair of unusually tame crowned cranes stood on the edge of a small marshy pool, and we got some great, front-lit portraits. The afternoon skies clouded up early, and by 5:15 P.M. the light failed. A heavy thunderstorm overtook us on our drive back to camp. *Photo highlight:* Crowned cranes.

LIONESS AND CUBS AT A KILL
500mm F4 lens, 1/250 sec. at f/5.6, Kodachrome 64.

You can minimize the blood and gore in your images of a kill by framing tightly on your subject, or by waiting until your subject moves away from the carcass.

CROWNED CRANE
500mm F4 lens, 1/500 sec. at f/8, Fujichrome 100.

The sunlit head and neck of this crowned crane was a perfect middle tone, although in this type of bright sunlight, you can just as easily base an exposure on the "sunny 16" rule, which is 1/ISO at f/16.

Day Thirteen:
Northern Masai Mara Reserve

Hyenas were today's entrée. We started the A.M. game drive under overcast skies. We headed back to look for yesterday's lion pride, and found four hunting lionesses. Unfortunately, each time they began to stalk, their prey strayed too far away.

We also saw four spotted hyena cubs at their den. Hyenas do a lot of sniffing when greeting one another, and this sometimes comical activity, coupled with some adults and young wrestling, burned up a lot of film.

We'd just finished breakfast and were standing around talking when one of our drivers noticed a cheetah chasing a herd of Thompson's gazelles on the horizon. We jumped into our vans, getting to the cheetah right after she captured a young fawn. The cat remained in full view as it consumed this little snack.

We headed back to the lions in the afternoon, and although they looked hungry and seemed attentive to passing game, nothing looked especially promising. Instead of wasting time on our last game drive, we left to fill in the final gaps in our safari coverage. In the next hour we shot the best lilac-breasted rollers of the trip, including one feeding on a large, migratory grasshopper; good tawny eagles; great giraffe portraits; and more Thompson's gazelles and topi babies.

One member of our group had missed the hyenas, and since his six-year-old grandson had commissioned him to make a hyena portrait, he was desperate for a good shot. We headed back to their den without much hope of finding them in the late afternoon, but luck was with us. Surprisingly, three black babies were out, and five others soon appeared. While we watched, two more emerged from another den. These were the smallest babies we'd seen, and we caught the mother nursing and grooming them. While we watched, a warthog walked to the den and climbed into it within 20 meters of the hyena mother. A minute later it changed its mind and wandered off. This was our clearest evening on safari, and we stayed with the hyenas until the golden light vanished. *Photo highlight*: Hyenas at their den.

SPOTTED HYENA WITH CUBS
500mm F4 lens, 1/250 sec. at f/4, Kodachrome 200 at ISO 250.

When I photograph wildlife, I try to capture traditional images, along with those that depict lesser-known aspects of an animal's behavior. Many think of hyenas only as cowardly scavengers, but they are devoted mothers and clan members.

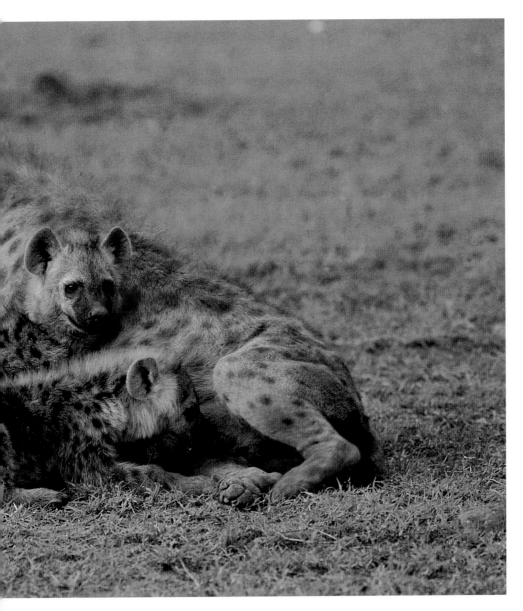

Day Fourteen: Northern Masai Mara Reserve to Nairobi

For the last leg of our journey, we flew to Nairobi, while our drivers drove there with our luggage. Because of the schedule, we passed on an early-morning game drive to give the drivers time to reach Nairobi before us so that our luggage would be in our rooms when we arrived. As it turned out, this was the first morning that it rained in the Mara, so we didn't miss anything.

The flight to Nairobi was uneventful; our drivers arrived with our luggage, and at 7:00 P.M. we headed to the Carnivore restaurant for a farewell dinner. Customs went smoothly, and at 12:30 A.M. we headed home.

Afterthoughts

It should be noted that there were other shooting opportunities with far more species than just the ones I have mentioned here. As usual, I filmed all the major herbivores, from dik-diks to waterbucks; lesser predators, such as bat-eared foxes and black-backed jackals; innumerable birds; and a contingent of reptiles, including chameleons, crocodiles, and monitor lizards. And, in reviewing this journal after my most recent safari just a few months ago, I realize that I've since been able to improve upon many of these images. But that's the point of keeping a journal. As I constantly discover, each trip is unique, and each offers new opportunities for great photographs. The experience never grows stale.

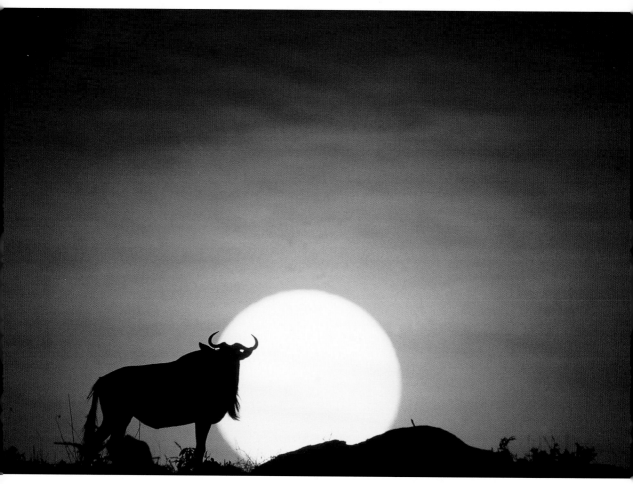

GNU AT SUNRISE
500mm F4 lens, 1/500 sec. at f/22, Kodachrome 64.

For sunrise and sunset shots, if you're not sure of the exposure and you have the time, bracket. Be careful when looking toward the sun with a long telephoto lens as this can seriously damage your eyes.

Personal Takes on This Safari

Besides our journals, Mary Ann and I also keep a daily record of the personal photo highlights for every member of our group. It is surprising how diverse these images can be. Highlights and tastes vary, and the same safari is quite different and personally unique for everyone. Here, then, is a list of each person's highlight, along with the amount of film each person used during the 13 days afield.

Photographer	Photo Highlight	Film Used
Ira	Brown weaver building its nest	95 rolls
Pat	Mother giraffe and baby	126 rolls
A.J.	Mother giraffe and baby	62 rolls
Howard	Ground-level dung beetle	101 rolls
Natalie	Leopard in tree	68 rolls
Carolyn	Leopard in tree	40 rolls
Joe	Leopard in tree	72 rolls
John	Portrait of kids in Nakuru	108 rolls
Ken	Liliac-breasted roller	81 rolls
Mary Ann	Thompson's gazelle with oxpeckers	65 rolls

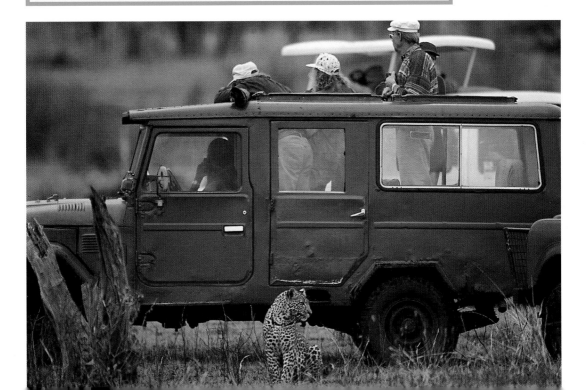

Resources for Safari Photographers

The following is a list of suppliers who you can contact to purchase, or acquire additional information about, much of the equipment mentioned in this book:

Ben-V Beanbags
Niall Benvie
Heughhead, Friockheim, by Arbroath
Angus DD11 4TY
Scotland
Zippered beanbags with nonskid, rubberized bottom surfaces and snap-lock straps—perfect for use on a Groofwinpod or vehicle rooftop

Charles Campbell
PHOTOnaturalist
P.O. Box 621454
Littleton, CO 80162
Choma-Zone Exposure System™ reference cards—to determine a subject's color tonalities

Concept Developments, Inc.
1123 South 6th Street
Brainerd, MN 56401
Stabilizer Quick Shot—a shoulder braced monopod that is ideal for filming action sequences with shorter lenses and is also handy for solo photographers

Daniel Poleschook Nature Photography
9225 N. Palmer Road
Spokane, WA 99207-9711
Stable Windowframe Mount II—for rock-solid lens support from a vehicle window; Action Head Teleflash System—increases flash output by 5.7 times the GN

L. L. Rue Enterprises
138 Millbrook Road
Blairstown, N.J. 07825
Groofwinpod—a lightweight camera and lens support; handy, often hard-to-find photo accessories

Lowepro
2194 Northpoint Parkway
Santa Rosa, CA 954407
Lowepro Photo Trekker AW—a photo backpack that can double as a gadget bag that conforms to carry-on luggage dimensions for most airlines

Joe McDonald's Wildlife Photography
73 Loht Road
RR# 2 Box 1095
McClure, PA 17841
Photography tours, workshops, and safaris in East and southern Africa—led jointly by Joe and Mary Ann McDonald

Nature's Reflections
P.O. Box 9
Rescue, CA 95672
A teleflash system offering an increase of three or four times a flash's GN

Really Right Stuff
P.O. Box 6531
Los Osos, CA 93412
Quick-release plates for dovetail-style monoballs; macro-photography focusing sliders and braces; flash arms that couple directly onto a large lens' tripod mount; flash extender posts to eliminate red-eye—useful with the Project-A-Flash System

Tiffen
90 Oser Avenue
Hauppague, N.Y. 11788
Slit and graduated neutral-density filters; graduated color filters; circular and warming-polarizer filters

Tory Lepp Productions
P.O. Box 6224
Los Osos, CA 93412
Project-A-Flash teleflash system—a lightweight teleflash frame and lens that increases a flash's GN two or three times, fits easily into a large photo vest, and is a cinch to assemble

Vested Interest
1425 Century Lane Suite 100
Dallas, TX 75006
Roomiest, most comfortable photo vests on the market today—the magnum version will accommodate four camera bodies in the front two pockets

Index